D0558382

IMAGES
of America
CHINATOWN
IN LOS ANGELES

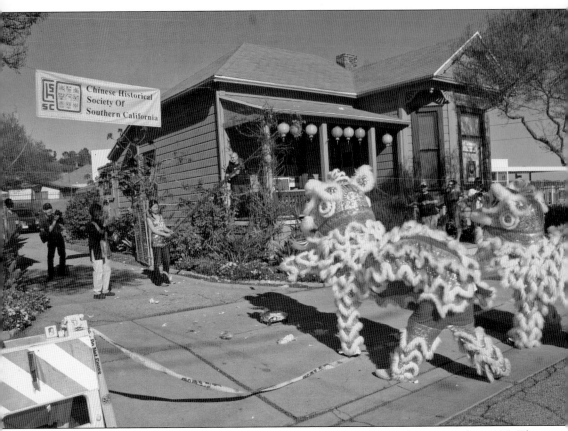

The Chinese Historical Society of Southern California was organized in November 1975. The purposes of the society are as follows: 1) to bring together people with a mutual interest in the important history and historical role of Chinese and Chinese Americans in Southern California; 2) to pursue, preserve, and communicate knowledge of this history; and 3) to promote the heritage of the Chinese and Chinese American community in support of a better appreciation of the rich, multicultural society of the United States. For more information, visit www.chssc.org. (Courtesy of Tom Eng.)

ON THE COVER: This 1951 photograph shows members of the Los Angeles Chinese Women's Club, who organized a fashion show in New Chinatown to demonstrate a traditional Chinese wedding. Pictured from left to right are Bessie Loo, Billie Lee, Mrs. Kem Lem, Maye Wong, Barbara Jean Wong Lee, Wong Antarne (the gentleman), Mrs. Shau Wa Chan, and Mrs. Louis Jake. The two children are Elsie Lew (left) and Ronnie Chan. They stand in front of the Gate of Maternal Virtue, which was built by attorney Y. C. Hong as a tribute to his mother and to all the mothers of the world. (Courtesy of the Herald Examiner Collection/Los Angeles Public Library.)

IMAGES
of America
CHINATOWN
IN LOS ANGELES

Jenny Cho and the
Chinese Historical Society of Southern California

ARCADIA
PUBLISHING

Published by Arcadia Publishing
Charleston SC, Chicago IL, Portsmouth NH, San Francisco CA

Printed in the United States of America

Library of Congress Control Number: 2008936544

For all general information contact Arcadia Publishing at:
Telephone 843-853-2070
Fax 843-853-0044
E-mail sales@arcadiapublishing.com
For customer service and orders:
Toll-Free 1-888-313-2665

Visit us on the Internet at www.arcadiapublishing.com

This book is dedicated to the Los Angeles Chinatown community, past and present. And to my family, who encouraged me to follow my dreams

This photograph of Los Angeles Street commemorates the Moon Festival that was held on October 8 and 9, 1938.

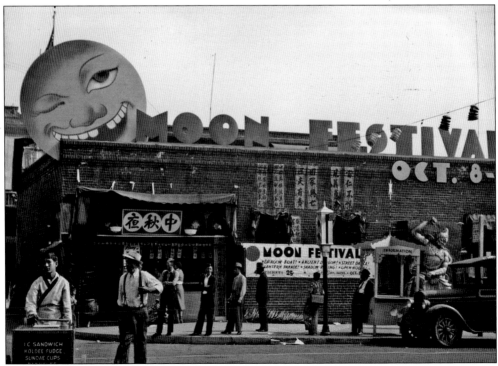

CONTENTS

Acknowledgments 6

Introduction 7

1. Old Chinatown 9

2. New Chinatown, China City, and World War II 55

3. Postwar Chinatown 89

4. New Generations in Chinatown 103

ACKNOWLEDGMENTS

My heartfelt gratitude goes to several individuals and institutions who made this book possible: Eugene Moy, William Gow, Gilbert and Gordon Hom, William Chun-Hoon, Susan Dickson, Tom Eng, Mei Ong, Al and Yvonne Chang, Albert and Margie Lew, Abraham and Ronald Chin, Susan Sing, Diane Poon, John Cahoon, Betty Uyeda, Margaret Kwong, Tyrus Wong, Carolyn Cole, Dace Taube, Betty Webb, Simon Elliott, Mauricio Hermasillo, Bill Frank, Erin Chase, Jill Cogen, Todd Gaydowski, Michael Holland, Jay Jones, Sheryl Nakano, Stephen Fong, Jeff Chan, Paul Louie, Irvin Lai, Miriam Suen, Hang Kwan Lee, Kenneth Klein, Robin Lee-Ramirez, Icy Smith, Marian Leng, Gay Yuen, Jeff Liu, Carol Wu, Linh Duong, Marjorie Lee, Ann Jung, Pamela Wong, Chris Lee, Dorothy Lew, Stanley Mu, Pauline Ong, Laura Ng, Lorien Bianchi, George Yu, Diane Poon, Michael Woo, Robert Chin, Harry Quillen, James W. Gin, Francine Redada, Keith Hedlund, Benjamin Winjum, Topher Osborn, and Tom Lance. I am especially grateful to my parents, Yushi Hu and Chin-Kuei Cho, and to Mary and Dennis Ebersole, Alex, Josh, Elizabeth, and my entire family for their love and support.

My deepest appreciation goes to the Chinese Historical Society of Southern California, Friends of the Chinatown Library, El Pueblo de Los Angeles Historical Monument, Chinese American Museum, Los Angeles Public Library, Los Angeles City Archives, University of Southern California, Chinatown Service Center, Seaver Center for Western History and Research, Huntington Library, Cathay Bank, UCLA, Visual Communications, Library of Congress, Chinatown Business Improvement District, First Chinese Baptist Church, Michael Dulay, Jason Dorff, Kong Chow Temple, Chinese American Citizens Alliance, and everyone at Glendale Community College for their support with this book.

It was an honor to meet the families of Old and New Chinatown and China City, who graciously shared their memories and mementos with me over several warm afternoons. Thank you to Wallace and Frank Quon, Lun F. and Dorothy Chan, Kenneth and Kellogg Chan, Al Soo-Hoo, David and Yuki Lee, Shirley and Jamie Fong, Leon and Bob Lee, Walter and Eileen SooHoo, Richard Chee, and John Young.

A big thank-you goes to Ruby Ling Louie for sharing her wisdom, knowledge, and writing skills (and chicken soup) with me. Many thanks to Hoover and William Louie for all their help.

I would like to extend a special acknowledgment to the legacy of Peter SooHoo Sr. and his entire family for their contributions to the history of Chinatown in Los Angeles. Without the generosity and gracious hospitality of Peter and Lucy SooHoo Jr., this book would not have been completed.

It was an honor to meet Leslee Leong, whose commitment to the preservation of her family history and the history of Chinatown is invaluable. I am indebted to Leslee Leong and Lisa See for meticulously documenting the stories of the See and Leung/Leong families. I am especially grateful to Eugene Moy, Susie Ling, William Gow, and Suellen Cheng for contributing their editorial expertise to this book. I would also like to thank Jerry Roberts, Devon Weston, and the entire team at Arcadia Publishing for supporting this project.

Unless otherwise indicated, the pictures in this book were provided by the Chinese Historical Society of Southern California or the author. The abbreviation "UCLA" denotes the Department of Special Collections, Charles E. Young Research Library, UCLA.

The research of this book was made possible by the Historical Society of Southern California (HSSC) John Randolph and Dora Haynes Research Stipend.

INTRODUCTION

The history of Chinatown in Los Angeles is as vibrant as the city itself. The individual stories of the people who lived and worked there tell the collective story of the community.

A total of two Chinese residents were recorded by the 1850 U.S. Census of the newly incorporated Los Angeles. By 1870, the number of Chinese slowly increased to a population of 200, who leased retail and living space from landlords such as Juan Apablasa and Sostenes Sepulveda. Chinese laborers were recruited by railroad companies and were often assigned to the most dangerous construction jobs. When the railroads were completed, more Chinese migrated to Los Angeles, seeking work in agriculture, laundries, general and herbal stores, domestic labor, restaurants, and other industries. From the 1850s to 1900, the Chinese population grew to approximately 3,000 residents, with additional growth limited by discriminatory exclusion laws. Comprised primarily of settlers from China's Sam Yup and Sze Yup districts, the Chinese enclave in Los Angeles became known as Old Chinatown and fell into decay during the early half of the 20th century. Anti-Chinese discrimination, arson, tong warfare, and a lack of political representation contributed to the neighborhood's decline.

Chinese settlers were extremely vulnerable to violence in their new environment. During the 1871 Chinese Massacre, a mob of 500 people attacked the Chinese residents of Calle de Los Negros. A total of 19 Chinese were lynched or shot to death. Anti-Chinese sentiment nationwide culminated in the congressional passage of the 1882 Chinese Exclusion Act, which suspended the immigration of Chinese laborers and was not repealed until 1943. The exclusion law also paved the way for the 1886 boycott of Chinese businesses, goods, and services organized by the Los Angeles Council of Trades and Labor. Restrictive housing covenants prevented the Chinese from buying homes, which inhibited their migration out of Old Chinatown.

Yet the Chinese persevered in the industries open to them and eventually established a strong economic niche in the produce market of Southern California. With the establishment of the City Market in 1909, the Chinese began moving out of Old Chinatown to build a community in the area around Ninth and San Pedro Streets. However, those who could not afford to leave Old Chinatown remained in a neighborhood that increasingly fell into disrepair. Rumors of an impending rail terminal on the site of Old Chinatown led to the widespread neglect of buildings. By the 1920s and 1930s, more Chinese left Old Chinatown to move into the single-family homes in the East Adams neighborhood.

In 1933, the city commenced the demolition of Old Chinatown to make way for the Los Angeles Union Passenger Terminal, otherwise known as Union Station. The future of Chinatown's residents remained uncertain until a group of pioneering Chinese Americans secured a new location for the displaced community in the present-day neighborhood of New Chinatown. Cofounder Peter SooHoo Sr. initiated a deal with Santa Fe Railway agent Herbert Lapham to purchase land for the area that eventually became New Chinatown.

New Chinatown was the first Chinese enclave in the country to be planned and owned by Chinese Americans. A plaque in Central Plaza commemorates the names of the founding members of the Los Angeles Chinatown Corporation, who pooled their resources to purchase land for 75¢ per square foot. On June 25, 1938, New Chinatown opened to great fanfare, as a crowd of over 30,000 gathered to watch Gov. Frank Merriam dedicate Central Plaza to the city.

Just a few blocks southeast of New Chinatown, another development called China City also opened to the public in 1938. China City was planned by socialite and civic leader Christine Sterling, whose connections to Harry Chandler of the *Los Angeles Times* enabled her to develop a "Chinese Movie Land" with shops, performances, rickshaw rides, and a movie set brought over from the film *The Good Earth*. Despite its reputation as a tourist attraction, China City was also home to the families of the merchants who worked there. In its short history, China City suffered two fires that led to its decline—and by the 1950s, China City was no more.

World War II galvanized the Chinatown community to demonstrate their patriotism through military service and participation in relief activities. Thousands of Chinese Americans served in the armed forces and fought valiantly for their country. Chinese American women joined the American Women's Voluntary Service to aid the war relief effort. Organizations such as the Chinese Consolidated Benevolent Association held fund-raising events such as China Nite and the Moon Festival, which attracted record numbers of visitors to Chinatown. Meanwhile, New Chinatown experienced a boom in tourism by attracting visitors who patronized businesses such as Dragon's Den and Man Jen Low restaurant. The Los Angeles Chinatown Corporation continued to raise funds for the expansion and improvement of Central Plaza. After World War II, West Plaza (also called Chungking Plaza) was built across the street from the West Gate to commemorate China's struggle during the war.

Yet all was not well during the postwar years as a bitter battle raged in Los Angeles City Hall to prevent the destruction of the remaining section of Old Chinatown. The triangular area bounded by Los Angeles and Alameda Streets was condemned for the construction of the Hollywood Freeway. By 1951, the remainder of Old Chinatown, except for a portion of the Garnier Block and Sanchez Alley, was to become a memory preserved in pictures and maps.

The passage of the 1965 Immigration and Nationality Act (also called the Hart-Cellar Act) introduced a new wave of Asian immigration to the United States by raising quotas to 20,000 people per Asian country. This resulted in the arrival of a sizeable number of Chinese immigrants to Chinatown, mostly from Hong Kong. Soon thereafter, the Vietnam War and the Cambodian genocide brought an influx of Southeast Asian refugees to Chinatown. The rapid increase in Chinatown's population drew attention to the lack of social services available to meet the needs of a growing multilingual, ethnically diverse community. Chinatown's residents demanded increased resources in health care, education, housing, and other areas. To support the youth in Chinatown, community leaders and activists organized programs such as the Los Angeles Chinese Drum and Bugle Corps, Chinatown Teen Council, Chinatown Teen Post, Chinese Lion Dancers of Los Angeles (now the Immortals Awaken Lion Club), Chinatown Kung Fu and Lion Dance Troupe, and Little Friends Playgroup. Thanks to the efforts of a number of volunteers and activists in the 1970s, Chinatown welcomed its first library and its first social services agency—Chinatown Service Center—as well as housing complexes for its senior citizens.

As more Chinese American residents migrated to suburbs such as Monterey Park, Alhambra, Rosemead, and Arcadia, revitalization efforts were initiated by community and city organizations to preserve Chinatown's history, neighborhoods, and economic viability. Spearheaded by the Community Redevelopment Agency of the City of Los Angeles, the Chinatown Redevelopment Project invested $600,000 in upgrades to Central Plaza in 1985. Annual events sponsored by the Chinatown Business Improvement District and other organizations continue to draw visitors to the neighborhood.

The story of Chinatown in Los Angeles is the story of a community. By no means complete, this small book provides a glimpse into the perseverance, courage, and spirit of this community. Over the course of a century and a half, Chinatown has evolved into a symbol for the diversity and enterprising spirit of Los Angeles.

One

OLD CHINATOWN

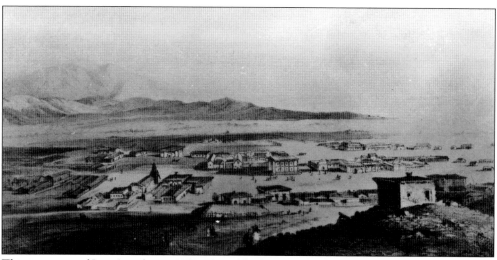

This is a view of Los Angeles in 1853. El Pueblo de Los Angeles was founded by pobladores in 1781 and became part of Mexico after the 1821 revolution. The city became incorporated in 1850, a few months before California achieved statehood. There were only two Chinese individuals recorded by the 1850 U.S. Census of Los Angeles—Ah Fou and Ah Luce. Both of them worked as domestic servants. (Courtesy of the Los Angeles City Archives.)

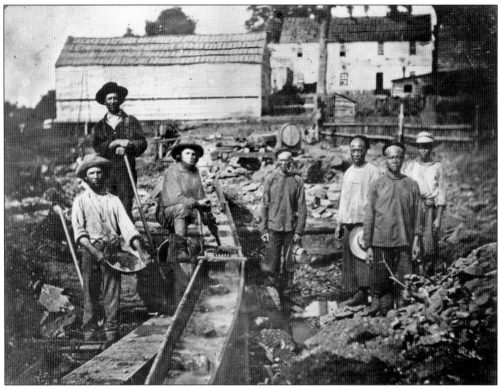

The Gold Rush was a major pull factor in attracting Chinese immigrants to "Gum Saan," or "gold mountain." As reflected by this 1851 photograph, Chinese miners often worked alongside other ethnic groups. To the right, three Chinese workers stand next to a flume box at the head of the Auburn Ravine in California. (Courtesy of the Huntington Library.)

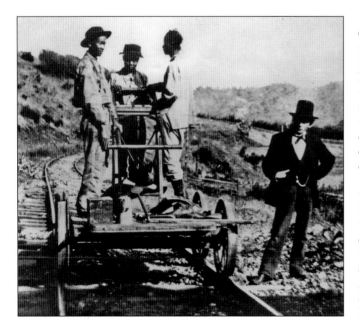

Chinese workers were recruited by the Central Pacific and Southern Pacific Railroad companies to build major railways that opened up the West to the rest of the country. They were often assigned the most dangerous jobs—including dynamiting. Pictured here in 1876, these Chinese workers ride a railcar in Lang, California. Lang was the location of the last spike driven in the new Southern Pacific railway connecting San Francisco and Los Angeles. (Courtesy of the Security Pacific Collection/ Los Angeles Public Library.)

Due to the massive volumes of laundry generated by waves of workers in California, Chinese immigrants quickly found a niche in the laundry business. The Chinese thrived in laundry work because it required low start-up capital and had less competition than other industries. This Chinese laundry was located in Wilmington, California, in the 1880s. (Courtesy of the Huntington Library.)

Much of Southern California resembled the Wild West during the 19th century. A single household might hire one or more Chinese immigrants to work as domestic servants, who not only performed chores for their employer but also participated in local entertainment. These Chinese workers participate in a "hold-up" play in Wilmington, California, in 1887. (Courtesy of the Huntington Library.)

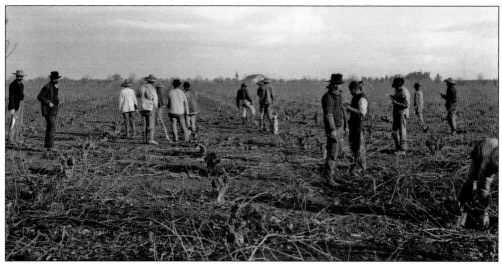

The Chinese made significant contributions to the agricultural industries of California. From Pasadena to Anaheim, Chinese workers packed and grew fruits and vegetables, tilled dams, and built irrigation facilities. The early landscape of Southern California was lined with farms, orchards, and vineyards that hired Chinese laborers. In the early 1900s, Chinese workers pruned grapes in a vineyard outside of Los Angeles. (Courtesy of California Historical Society Title Insurance and Trust Photograph Collection, Department of Special Collections, University of Southern California.)

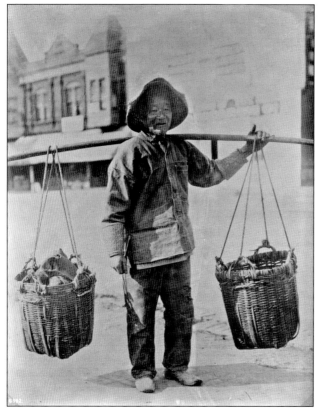

Chinese immigrants found work as vegetable peddlers and eventually enjoyed a near monopoly on the distribution of fresh produce in Los Angeles. This Chinese vegetable peddler carried his wares throughout Chinatown in the early 1900s. (Courtesy of the Peter SooHoo Sr. Collection.)

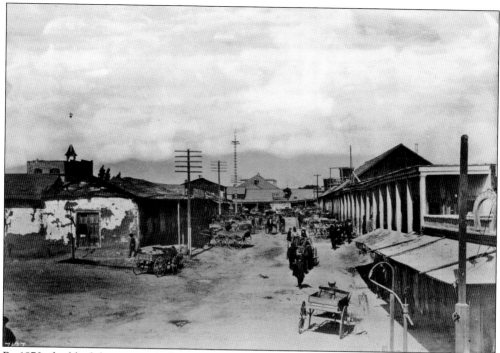

By 1870, the block known as Calle de Los Negros, or Negro Alley, became home to a settlement of approximately 200 Chinese residents in the enclave that became known as Old Chinatown. (Courtesy of California Historical Society Title Insurance and Trust Photograph Collection, Department of Special Collections, University of Southern California.)

On the east side of Negro Alley, these signs show the presence of Chinese laborers and the businesses that supported them. Chinese laborers rented "furnished" living spaces and were contracted by the employment office for various jobs. The Sam Sing butcher shop sold pork to the growing community in Old Chinatown. Part of the 1871 Chinese Massacre occurred on the east side, opposite the Coronel House. (Courtesy of UCLA.)

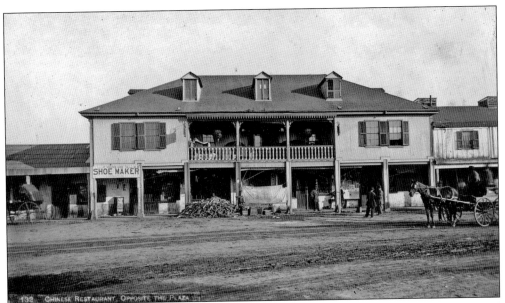

Built by a pioneer Mexican family on the east side of the Los Angeles Plaza, the Lugo House was initially the site of St. Vincent's—the first college in the city. By 1889, its spaces were leased to Chinese businesses and organizations, which made it an integral part of Old Chinatown. (Courtesy of the Peter SooHoo Sr. Collection.)

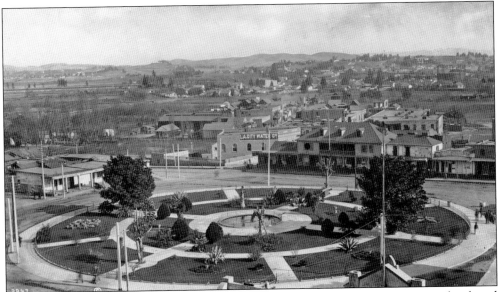

By the 1890s, the Los Angeles Plaza evolved from its dusty beginnings to a more developed thoroughfare for the residents of the city. Old Chinatown was at the center of town, with new buildings occupied by the Chinese across Alameda Street. The Lugo House is visible at the center right of the photograph. (Courtesy of the Peter SooHoo Sr. Collection.)

A Chinese vegetable peddler wrangles his two horses near Mon Chong and Company on Apablasa Street. The street was named after Chilean landowner Juan Apablasa, who died in 1863. The Chinese settlement gradually expanded to Apablasa and Marchessault Streets in Old Chinatown. (Courtesy of the Peter SooHoo Sr. Collection.)

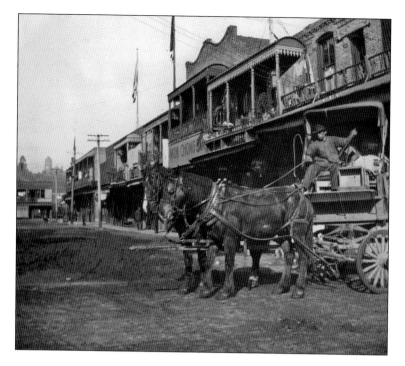

The intersection of Juan and Napier Streets functioned as a stable and parking lot for horses and wagons until the 1920s. The space was utilized by Chinese produce workers in Old Chinatown who sold fruits and vegetables throughout the city. (Courtesy of the Peter SooHoo Sr. Collection.)

Old Chinatown initially developed as a bachelor society of Chinese men who intended to save enough money to return to China. (Courtesy of the Peter SooHoo Sr. Collection.)

Bulletins posted on outdoor walls were the main source of news for the Chinese community in Old Chinatown. (Courtesy of the Seaver Center for Western History and Research, Los Angeles County Museum of Natural History.)

Early Chinese immigrants wore their hair in queues, which were single long braids that signified their deference to the Manchu emperor. They sought the services of Chinese barbers who were familiar with the hairstyle. (Courtesy of the Huntington Library.)

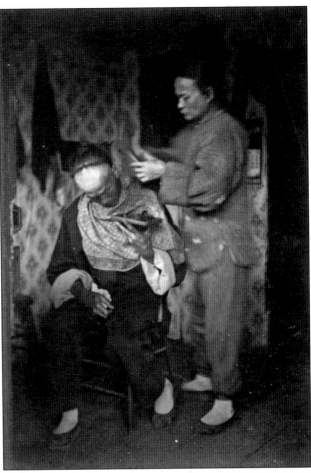

Chinese customers patronized this barbershop on the east side of Alameda Street, south of Marchessault Street. It offered a haircut for 25¢ and a shave for 15¢ in the 1890s. (Courtesy of the Peter SooHoo Sr. Collection.)

By 1872, approximately 15 Chinese laundries were doing business in Los Angeles. Most of them functioned as hand laundries that provided door-to-door service to customers. When the Los Angeles City Council tried to pass a $5 tax on hand laundries, many Chinese opted to serve a five-day jail sentence in lieu of obeying the law targeted at them. (Courtesy of the Seaver Center for Western History and Research, Los Angeles County Museum of Natural History.)

LOS ANGELES TRADES AND LABOR COUNCIL.
PLEDGE. (No. 1.)

I hereby pledge myself that, from and after the first day of May, 1886, I will discontinue the patronage of Chinese in any capacity, and the purchase of any article made by Chinese in America. I also promise, meanwhile, to encourage and support any person other than Chinese engaged in the vegetable and laundry business. And after the said first day of May I pledge myself to withhold my patronage from all individuals or firms who, after that date, shall employ Chinese in any capacity, rent houses or grounds to them, or sell goods manufactured by the Chinese in America.

Name,...

Residence,...

In 1886, the Los Angeles Trades and Labor Council launched a major anti-Chinese campaign that called for a boycott of all businesses that employed Chinese workers and all goods made by Chinese labor. Participants signed these pledges to fire their Chinese workers immediately and replace them with "white help." The boycott ended when the Chinese refused to provide fresh produce to the city.

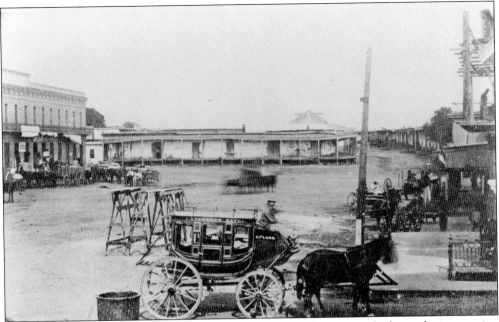

The 1871 Chinese Massacre occurred in this section of Old Chinatown, which was the intersection of Los Angeles and Arcadia Streets, with Negro Alley running to the north. The central building is the Coronel House, named after landowner Antonio F. Coronel. On October 23, 1871, a conflict between two Chinese factions escalated into a shoot-out that killed a Caucasian man named Robert Thompson. When word spread about Thompson's death, a mob of 500 people descended on Old Chinatown, pulling Chinese residents out of their homes and looting their belongings. (Courtesy of California Historical Society Title Insurance and Trust Photograph Collection, Department of Special Collections, University of Southern California.)

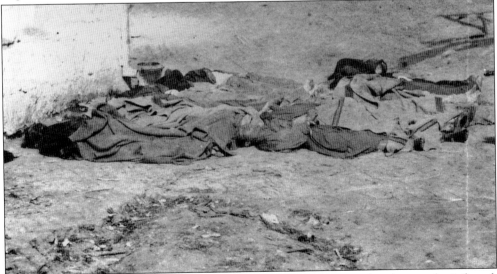

The morning after the massacre, two rows of Chinese corpses were lined up at the jail yard. Fifteen Chinese had been lynched, and four were shot to death. A total of 19 victims were killed in one of the deadliest episodes of violence against the Chinese in U.S. history. (Courtesy of the Shades of L.A. Archives/Los Angeles Public Library.)

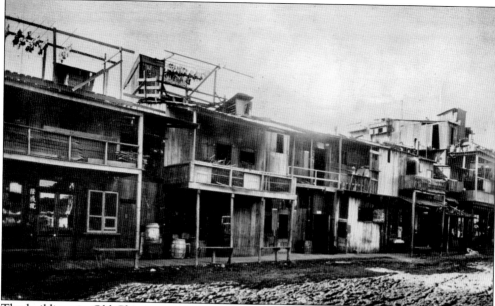

The buildings in Old Chinatown were poorly constructed and vulnerable to fire. Two arsons occurred in 1886 and 1887 that burned down most of Negro Alley in Old Chinatown. This block of Marchessault Street consisted of wooden structures with roof racks used for drying meat.

In 1882, Castelar School was opened by the City of Los Angeles. The school and its location on Castelar Street were named after the last president of the Spanish Republic in California. The original four-room structure burned down in 1903 and was replaced by a new wooden building in 1904. After the demolition of Old Chinatown, many Chinese residents moved to this neighborhood and attended classes in this wooden schoolhouse. The building was torn down in 1975 because it did not comply with earthquake standards.

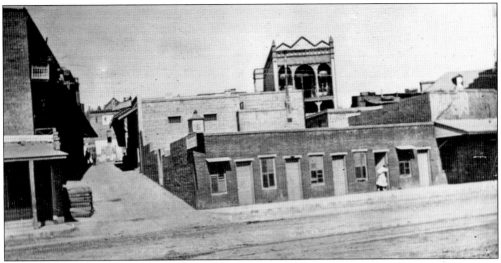

Old Chinatown initially developed as a bachelor society of Chinese men. Chinese women were often brought over to the United States by organizations called tongs and forced to work in brothels—including this four-door building on Alameda Street where a lone woman looks for customers. Such activities continued despite the passage of the 1875 Page Act, which banned the entry of immigrant women for the purpose of prostitution. (Courtesy of the Shades of L.A. Archives/Los Angeles Public Library.)

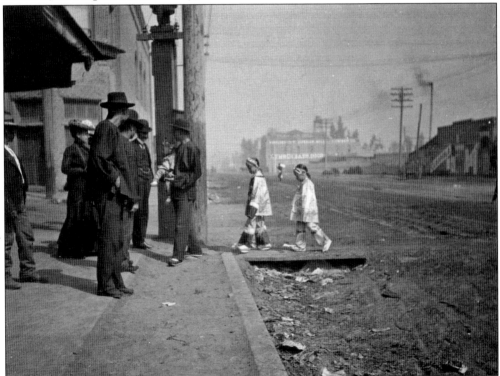

Two Chinese women cross Alameda Street during the 1902 Feast of the Dead. This view looking north down Alameda shows the undeveloped landscape of Los Angeles. (Courtesy of the Huntington Library.)

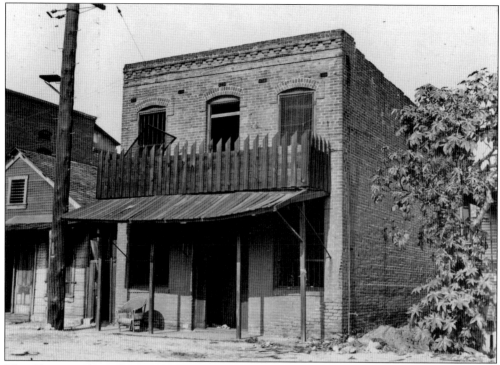

The Chinese jail was located on Apablasa Street in Old Chinatown. Chinese tongs used this facility to incarcerate any member who committed a minor offense. During the late 19th century, the Los Angeles Police Department seldom involved themselves in the community. (Courtesy of UCLA.)

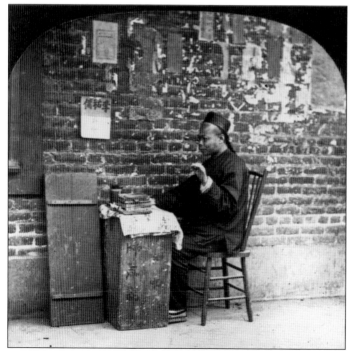

Early Chinese fortune-tellers also served as letter writers for residents who wanted to send mail back to China. This fortune teller set up shop on a sidewalk in Old Chinatown, next to a wall that was used to post news and bulletins for the community. (Courtesy of the Seaver Center for Western History Research, Los Angeles County Museum of Natural History.)

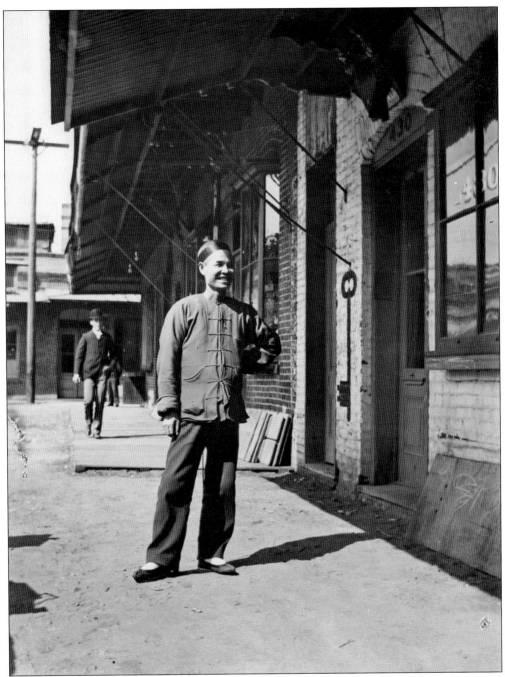

This man was identified as the "Old Chinatown Blacksmith." (Courtesy of California Historical Society Title Insurance and Trust Photograph Collection, Department of Special Collections, University of Southern California.)

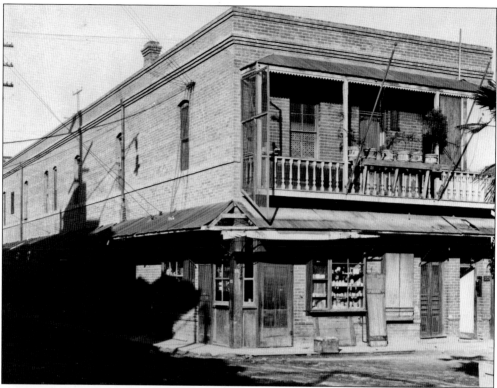

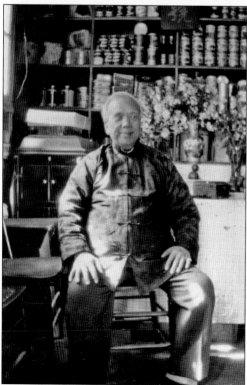

In the 1890s, SooHoo Leung opened the Sang Yuen Company general store on Apablasa Street in Old Chinatown. Apablasa Street was home to a number of businesses that catered to the local Chinese community. Merchants lived inside or nearby their stores. (Courtesy of the Peter SooHoo Sr. Collection.)

SooHoo Leung owned the Sang Yuen Company general store on Apablasa Street and lived in one of the few single-family homes in Old Chinatown. The store was a family-run enterprise, where labels were pasted on canned goods with homemade flour and water. Pictured at left, the jovial owner smiles inside Sang Yuen Company during Chinese New Year in 1940. His family consisted of six daughters and three boys, including the cofounder of New Chinatown, Peter SooHoo Sr. (Courtesy of the Peter SooHoo Sr. Collection.)

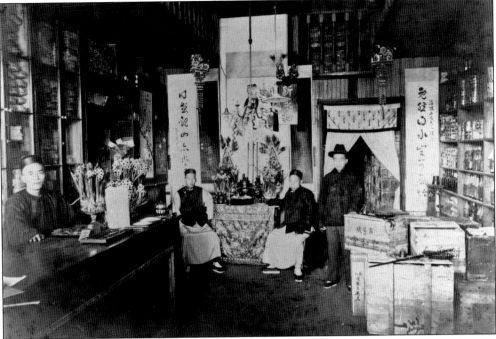

In 1891, Ow Bue Lew established the Sun Wing Wo general store and herbal shop in the historic Garnier Building on Los Angeles Street. The store served many functions for the Chinatown community, including an early form of health care through its distribution of Chinese herbs and medicine. It also offered a letter writing service for Chinese immigrants to send letters and money back to families in China. (Courtesy of Billy Lew, El Pueblo de Los Angeles Historical Monument and the Chinese American Museum.)

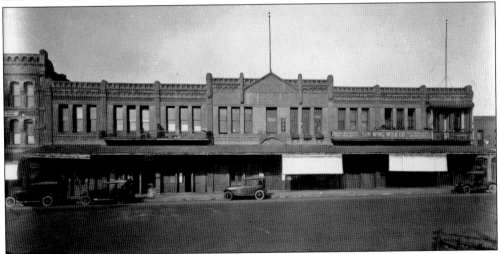

The Garnier Block was built in 1890 by a French banker and landowner named Philippe Garnier. Located on Los Angeles Street between Arcadia Street and the Los Angeles Plaza, the Garnier Block was home to Chinese churches, schools, organizations such as the Chinese Consolidated Benevolent Association, and businesses such as the Sun Wing Wo general store and the Young Wo Tong herbal store. (Courtesy of the Seaver Center for Western History and Research, Los Angeles County Museum.)

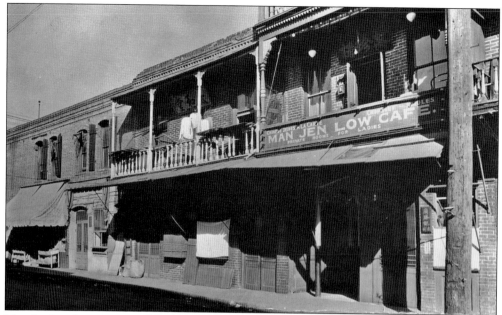

Man Jen Low became one of the first restaurants to open in Old Chinatown. Owner Woo Chung Lim (also known as Woo Hoy) moved his restaurant from First and Mateo Streets to 309½ Marchessault Street in Old Chinatown. Signs in Chinese and English display the name of the business, which means "House of 10,000 Treasures." When Old Chinatown was torn down to build Union Station, Man Jen Low relocated to New Chinatown. (Courtesy of David Lee.)

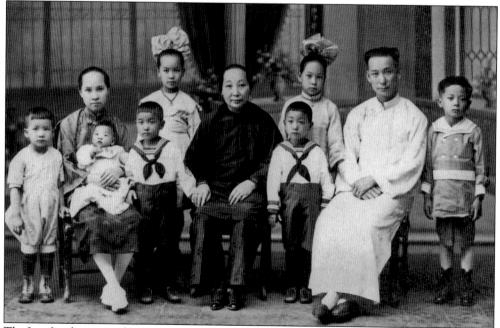

The Lee family operated Man Jen Low restaurant in Old Chinatown. Seen here in 1923 are, from left to right, (first row) David Lee, Lum Shee, baby Jenny, Merton, Woo Fong See, Norman, Fon Lee, and Walter Lee; (second row) Rose and Kau Lee. Fon Lee (also known as Woo Pak Hun and Woo Fon Lee) became one of the founders of New Chinatown. (Courtesy of David Lee.)

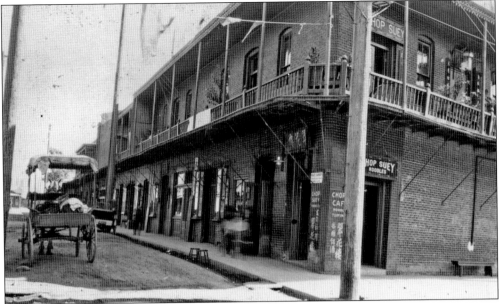

As one of the early restaurant owners in Old Chinatown, Quon Soon Doon opened Tuey Far Low at the corner of Alameda and Marchessault Streets. In the 1930s, he became one of the founders of New Chinatown and moved his restaurant to the corner of Ginling Way and Sun Mun Way in Central Plaza. (Courtesy of the Peter SooHoo Sr. Collection.)

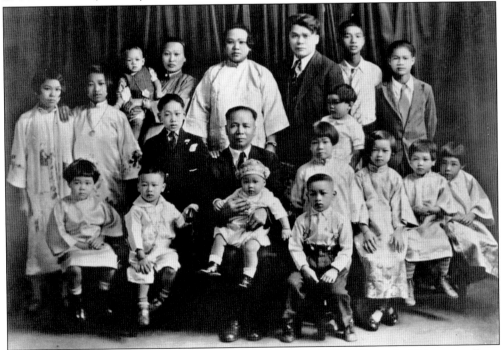

By 1931, Quon Soon Doon and his family lived at 943 West College Street in Chinatown. From left to right are (first row) Lorley, Ben, William, Quon Soon Doon holding Wallace, George, Edith, Gee Guwe, Betty, and Mary; (second row) Katie, Margie, Quon Soon Doon's second wife holding baby, Yu Hai "Mama," James, Janet, Harry, and Tommy Quon. (Courtesy of Wallace Quon.)

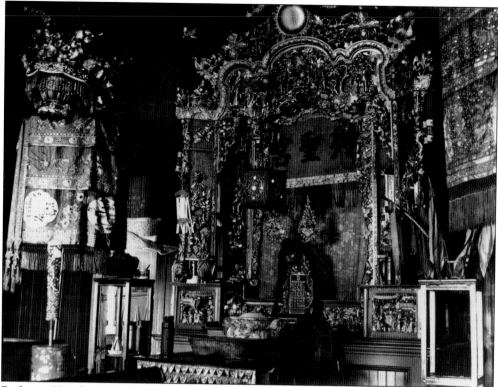

Built in 1891, the Kong Chow Temple was located in Old Chinatown's Ferguson Alley. Also known as the Kong Chew Maei Temple, it featured rich carvings inside the building. After the demolition of Old Chinatown, the temple relocated to Broadway Street. (Courtesy of UCLA.)

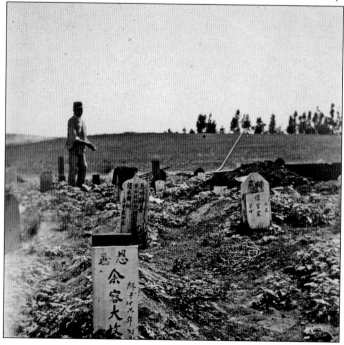

The Chinese Cemetery Shrine at Evergreen Cemetery was one of the few places where the Chinese were allowed to bury their dead in the 19th century. The Chinese community continued to experience discrimination from Los Angeles cemeteries well into the 20th century, where mourners were encouraged to seek burial spaces elsewhere. Pictured in 1897, a Chinese man visits the grave of Wong Chee in Evergreen Cemetery. (Courtesy of the Huntington Library.)

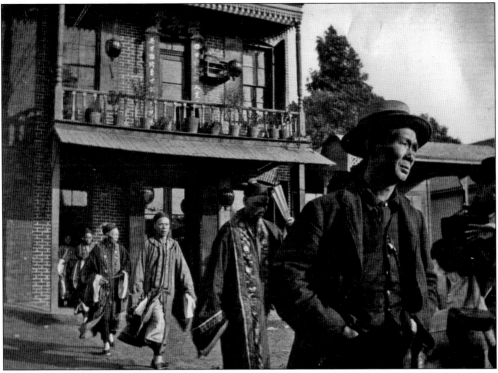

A group of Chinese men exit 802 Juan Street in Old Chinatown during the late 19th century. The location featured a general merchandise store operated by Mee Wo Chong on the first floor and a temple upstairs. Chinese workers from all over Southern California congregated in such buildings to socialize and learn news. (Courtesy of the Peter SooHoo Sr. Collection.)

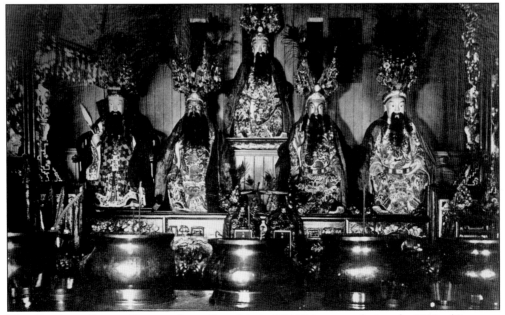

This "joss house" was a Chinese place of worship in Old Chinatown during the 1890s. (Courtesy of UCLA.)

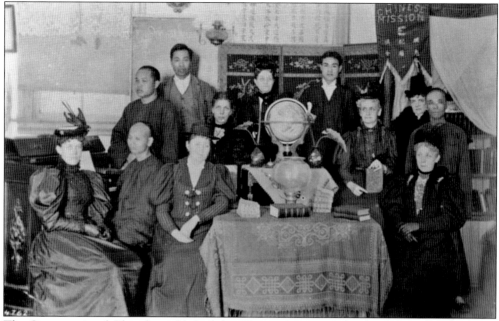

The Congregational Church established the Chinese Mission School to bring Christianity to Old Chinatown. The teachers provided lessons in English language and religion to the growing Chinese settlement. (Courtesy of California Historical Society Title Insurance and Trust Photograph Collection, Department of Special Collections, University of Southern California.)

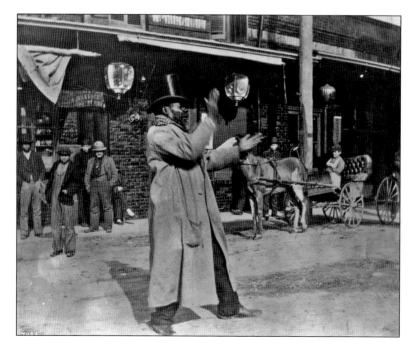

Peter Johnson (pictured here in the 1890s) was an African American preacher who gave public sermons on the streets of Old Chinatown. He attracted curious audiences from all ethnic backgrounds. (Courtesy of the Peter SooHoo Sr. Collection.)

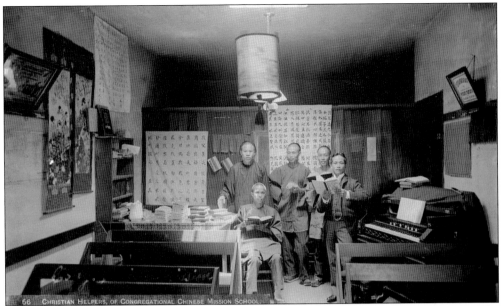

The Congregational Chinese Mission School was established by Rev. Ira Condit in 1876. The Lord's Prayer is written in Chinese on the banner to the left of the men. The banner behind the men reads, "Christianity is the light in the morning, and all people on earth come to worship." Chinese Bibles and hymnal books are on the table. (Courtesy of California Historical Society Title Insurance and Trust Photograph Collection, Department of Special Collections, University of Southern California.)

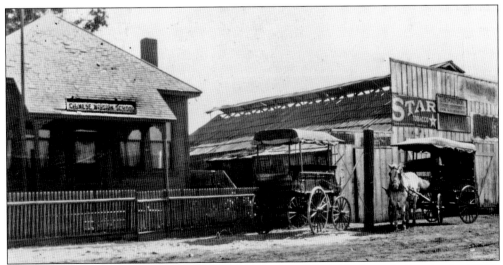

The Chinese Mission School was located next to Lew Way's blacksmith shop in the 1910s. (Courtesy of the Peter SooHoo Sr. Collection.)

HARPER'S WEEKLY

A JOURNAL OF CIVILIZATION

Vol. XXXVIII.—No. 1965.
Copyright, 1894, by HARPER & BROTHERS.
All Rights Reserved.

NEW YORK, SATURDAY, AUGUST 18, 1894.

TEN CENTS A COPY.
FOUR DOLLARS A YEAR.

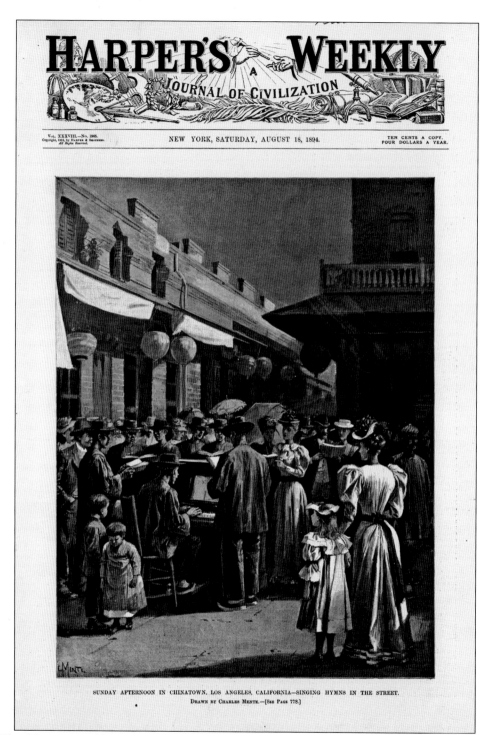

SUNDAY AFTERNOON IN CHINATOWN, LOS ANGELES, CALIFORNIA—SINGING HYMNS IN THE STREET.
DRAWN BY CHARLES MENTE.—[SEE PAGE 778.]

This *Harper's Weekly* cover from August 18, 1894, depicts a group of Christians engaged in a Sunday ritual of singing hymns in Old Chinatown. Missionaries began to establish a presence in Old Chinatown in an effort to convert the "heathen chinee." They provided English lessons to Chinese residents, who appreciated the inexpensive opportunity to improve their English.

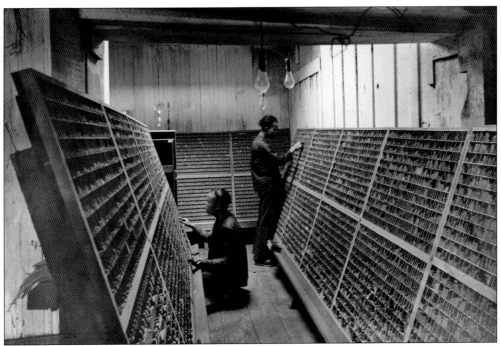

By 1900, a number of Chinese newspapers and printing presses were established to disseminate news to Chinese communities. These compositors worked at a Chinese printing facility in Los Angeles, where they hand-set type and had to know the locations of an estimated 10,000 characters contained in the large cases above. (Courtesy of California Historical Society Title Insurance and Trust Photograph Collection, Department of Special Collections, University of Southern California.)

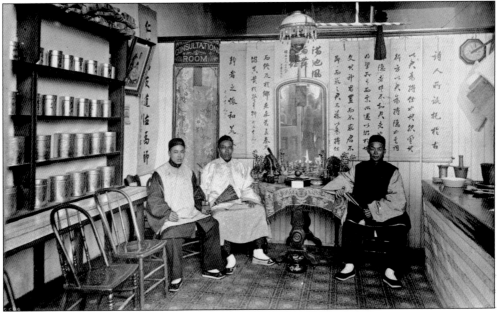

Chinese herbal stores offered an early form of health care to customers in Los Angeles. (Courtesy of California Historical Society Title Insurance and Trust Photograph Collection, Department of Special Collections, University of Southern California.)

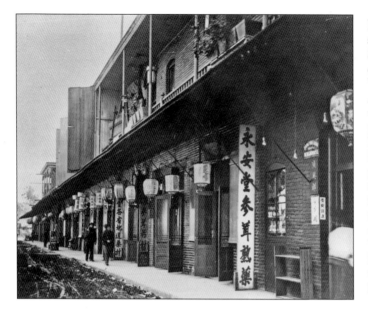

Festive lanterns lined the storefronts of Marchessault Street in Old Chinatown during Chinese New Year in the early 1900s. A family association was located next door to Dun Sow Hong, an herbal store owned by the Mu family. During the parade, money would be collected from the cups for various associations or the community. (Courtesy of the Seaver Center for Western History and Research, Los Angeles County Museum of Natural History.)

Chinese musicians performed at the local Chinese theater or during Chinese New Year celebrations. The Chinese theater was located between Ferguson Alley and Marchessault Streets and held performances of Chinese operas. These Chinese men and boys carry their instruments past 201 Ferguson Alley in Old Chinatown in the 1910s. (Courtesy of the Seaver Center for Western History and Research, Los Angeles County Museum of Natural History.)

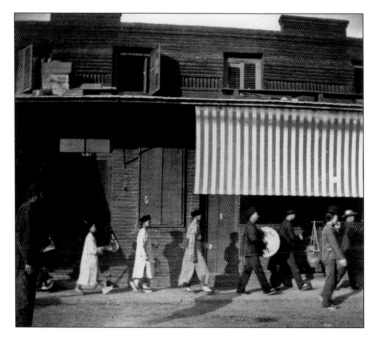

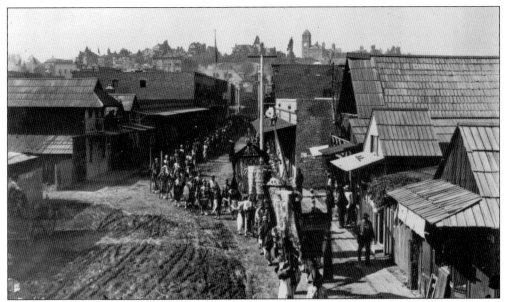

By 1895, the Chinese community in Los Angeles was allowed to hold public celebrations of Chinese New Year. This parade proceeds down Marchessault Street, one of the main thoroughfares of Old Chinatown. The street was named after Damien Marchessault, who served as mayor of Los Angeles in the 1860s. (Courtesy of the Seaver Center for Western History and Research, Los Angeles County Museum of Natural History.)

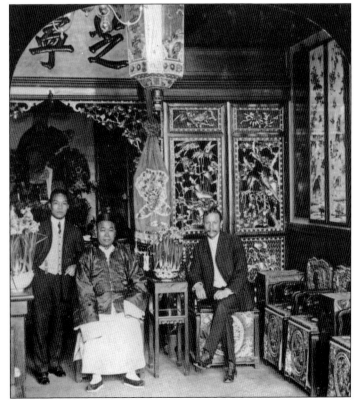

The proprietor of Gee Tong Ning celebrates Chinese New Year with a guest. Chinese New Year is a time to clean house, settle old debts, and make offerings for a prosperous year. (Courtesy of the Seaver Center for Western History and Research, Los Angeles County Museum of Natural History.)

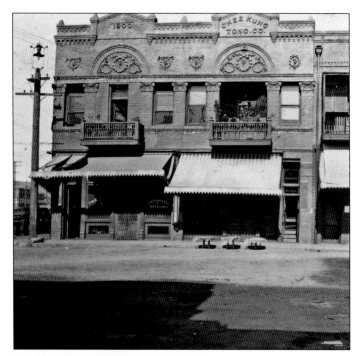

Founded in San Francisco, the Chee Kung Tong was a Chinese fraternal order dedicated to the overthrow of the Manchu government in China. Also known as the Chinese Freemasons, the political group established a Los Angeles branch at 315½ Apablasa Street that raised funds on behalf of Dr. Sun Yat-Sen. The top of the building bears the date 1900 to commemorate the transition of Chinatown's architecture from wooden to brick buildings. (Courtesy of the Peter SooHoo Sr. Collection.)

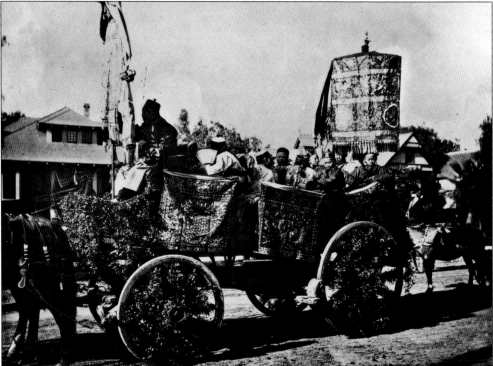

In 1897, this Chinese merchant float participated in the La Fiesta Parade in Los Angeles. Los Angeles was a town of rich ethnic and cultural diversity, and Chinatown was invited to participate in these annual celebrations organized by the Los Angeles Chamber of Commerce. (Courtesy of the Peter SooHoo Sr. Collection.)

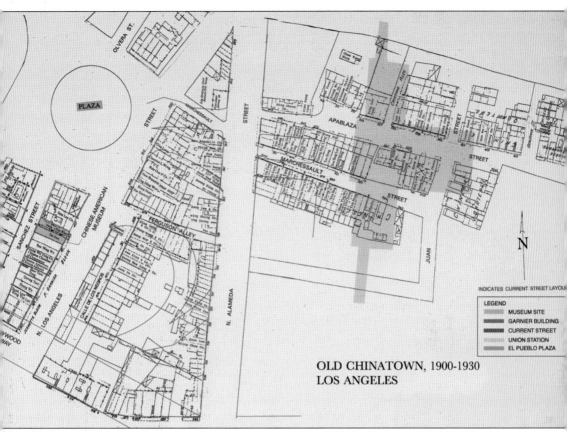

This is a map of Old Chinatown dating between 1900 and 1930. (Courtesy of El Pueblo de Los Angeles Historical Monument and the Chinese American Museum.)

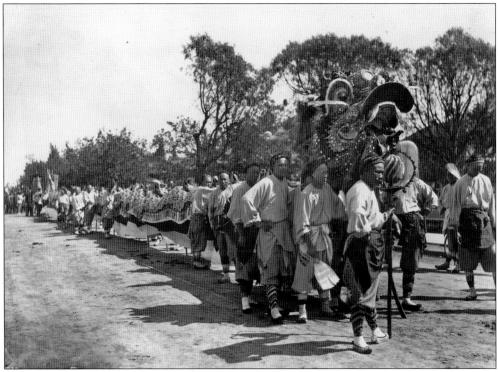

This 100-foot-long Golden Dragon was carried by Chinese men during the La Fiesta de Los Angeles parade in May 1901. The Chinese contingent of the parade was three blocks long and made such a positive impression that the organizing committee sent a note of thanks to the Chinese consulate for its support. The event welcomed Pres. William McKinley to Los Angeles. (Courtesy of the Peter SooHoo Sr. Collection.)

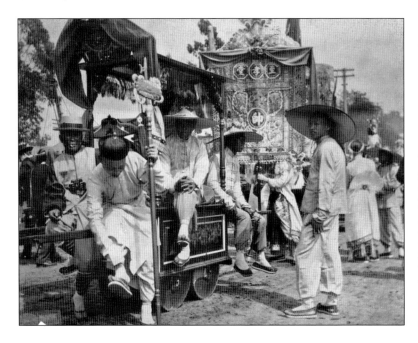

These Chinese festival-goers also wait to join the La Fiesta de Los Angeles parade that welcomed Pres. William McKinley to Los Angeles in 1901. (Courtesy of the Peter SooHoo Sr. Collection.)

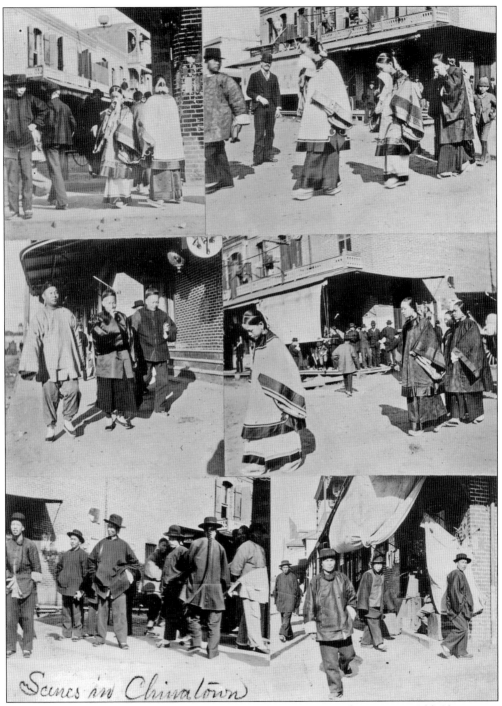

Scenes in Chinatown

This montage of photographs shows groups of Chinese men and women in Old Chinatown during Chinese New Year in 1901. Since Chinese ethnic enclaves at the turn of the 20th century were predominantly bachelor societies, the presence of Chinese women was extremely rare. (Courtesy of the Seaver Center for Western History and Research, Los Angeles County Museum of Natural History.)

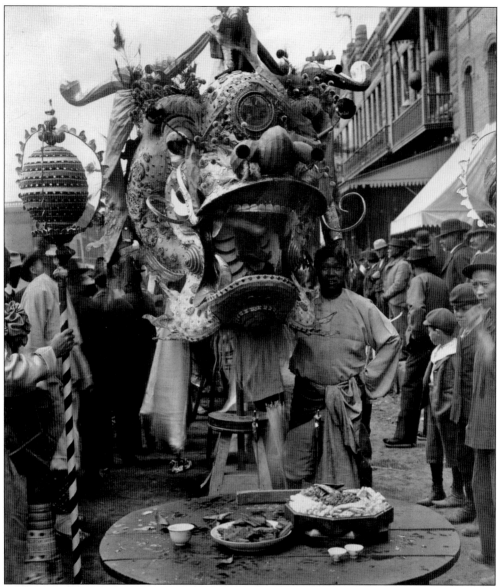

Offerings for this great dragon were placed in front of the Garnier Building in Old Chinatown during the 1900 La Fiesta de Los Angeles. To the left, a man holds the ceremonial orb that dictates the dragon's movements. The table of offerings features selections of food and tea. (Courtesy of the Peter SooHoo Sr. Collection.)

Two Chinese children performed during the Feast of the Dead celebration that was held in October 1902. (Courtesy of the Huntington Library.)

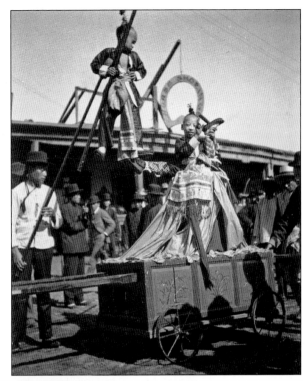

The Chinese Presbyterian Church offered classes in English to Chinatown's children.

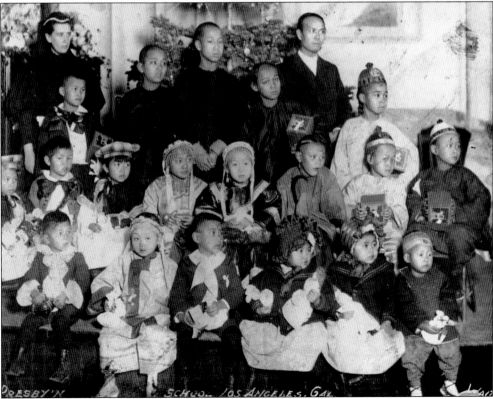

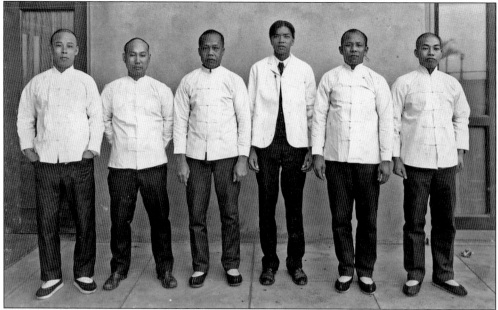

Chinese workers were hired by the Jonathan Club in 1907. The Jonathan Club was an elite social club located in the Pacific Electric building in downtown Los Angeles. (Courtesy of the Huntington Library.)

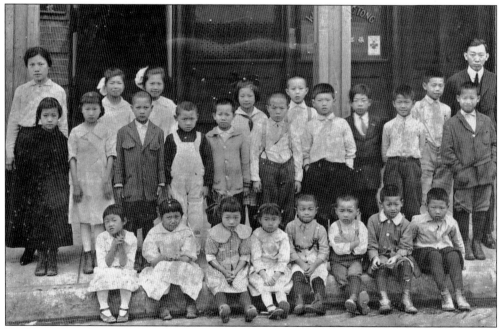

By the early 20th century, Old Chinatown evolved from a bachelor society with few women to a neighborhood with families. The Chinese Methodist Church offered classes to Chinatown's children in the Lugo House on Los Angeles Street. The class of 1909 was taught by Mrs. Leung Jeung, who was considered the moral authority in Old Chinatown. The pioneering Leung family made indelible contributions to the history of Old and New Chinatown, spanning several generations. (Courtesy of Leslee See Leong.)

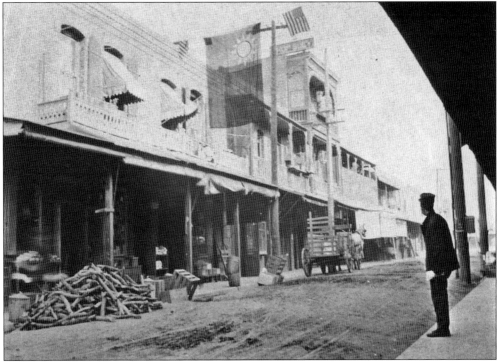

The year 1911 marked the end of the Qing Dynasty and the founding of modern China. Old Chinatown celebrated the establishment of the republic and the achievements of China's leader, Sun Yat-Sen, by raising the Chinese flag above Marchessault Street. (Courtesy of the Huntington Library.)

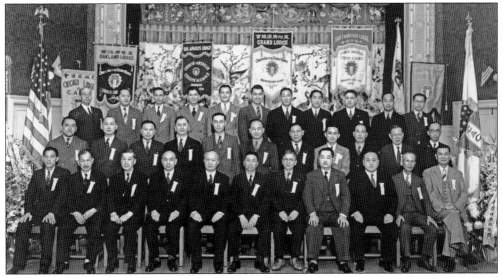

The Los Angeles Lodge of the Chinese American Citizens Alliance (CACA) was established in 1912 to give Chinese Americans a voice in the community. CACA dates back to 1895, when a group of Chinese Americans who had been rejected by the Native Sons of the Golden West founded the organization in San Francisco. Pictured here, CACA held its 17th Biennial National Convention in 1939. (Courtesy of the Peter SooHoo Sr. Collection.)

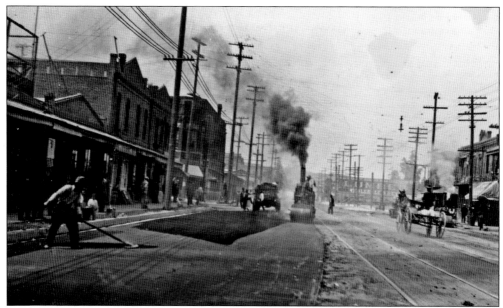

The paving of Alameda Street in the 1910s ushered in a new mode of transportation by automobile. By the early 1930s, the horse-and-wagon mode of transportation was on its way out. (Courtesy of the Peter SooHoo Sr. Collection.)

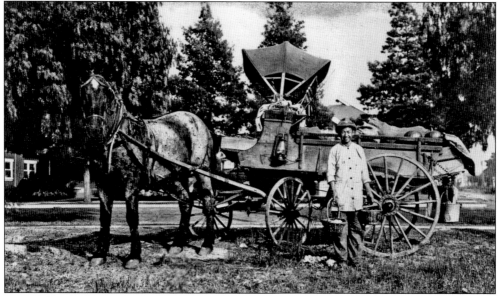

Pictured here in 1914, Chan Yip Leong lived in Old Chinatown and delivered produce to the neighborhood from his horse-drawn wagon. He was the grandfather of Marjorie Chun-Hoon, whose family made enduring contributions to New Chinatown. (Courtesy of the Shades of L.A. Archives/Los Angeles Public Library.)

Fong See was one of the most successful merchants in Chinatown. His businesses included the F. Suie One Company and F. See On stores with locations in Chinatown, downtown Los Angeles, Pasadena, as well as auctions in Long Beach. From left to right are (first row) Eddy; Fong See; Sissee; See's wife, Letticie "Ticie"; and Bennie See; (second row) Ray and Ming See. (Courtesy of Leslee See Leong.)

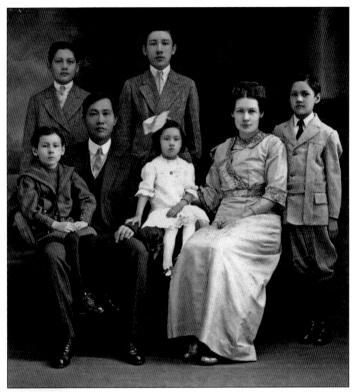

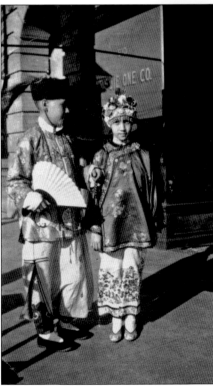

Eddy and Sissee See stand outside the F. Suie One store at 510 Los Angeles Street. The store was one of several owned by their father, Fong See, whose family is the subject of the book *On Gold Mountain: the One-Hundred-Year Odyssey of My Chinese-American Family* by Lisa See. (Courtesy of Leslee See Leong.)

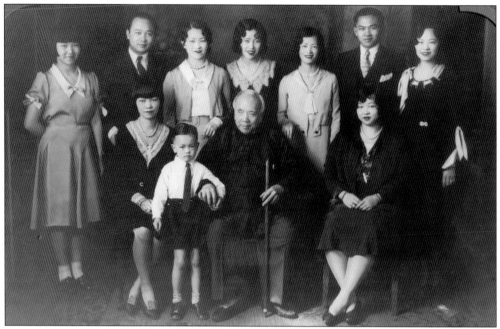

Pictured here in 1930, this photograph shows three generations in the SooHoo family. SooHoo Leung owned the Sang Yuen store in Old Chinatown. Peter SooHoo Sr. was the cofounder of New Chinatown. From left to right are (first row) Lillie Leung SooHoo, Peter SooHoo Jr., SooHoo Leung, Pearl SooHoo Ong; (second row) Eleanor SooHoo Yee, Peter SooHoo Sr., Lucille SooHoo Yee, Maye SooHoo Wong, Mary SooHoo Tom, David SooHoo, and Jessie SooHoo Ming. (Courtesy of the Peter SooHoo Sr. Collection.)

Pictured here in 1933, Ferguson Alley was one of the earliest thoroughfares in Old Chinatown. It was home to the Kong Chow Temple, Boman Chung's barbershop, Jerry's Joynt, Hung Wo Hong herbal store, and various tenants. By the early 1950s, Ferguson Alley was torn down to make way for Hollywood Freeway access improvements. (Courtesy of the Los Angeles City Archives.)

The death of Sun Yat-Sen was observed by a day of mourning on April 12, 1925, in Chinatown. Chinese leaders organized a parade and memorial service that featured speakers from local organizations, tongs, and the Chinese Presbyterian Church. The motorcade began at Apablasa Street and proceeded down Los Angeles Street to the Jake Wah Ning Theater on Court Street. Dr. Sun touched the hearts of many Chinese Americans, especially because he was from the Guangdong province in China. (Courtesy of UCLA.)

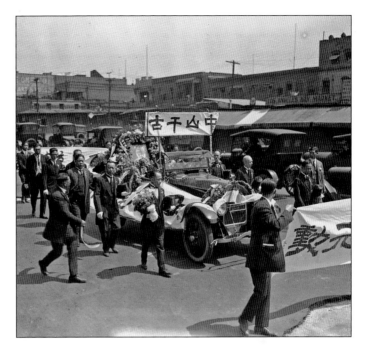

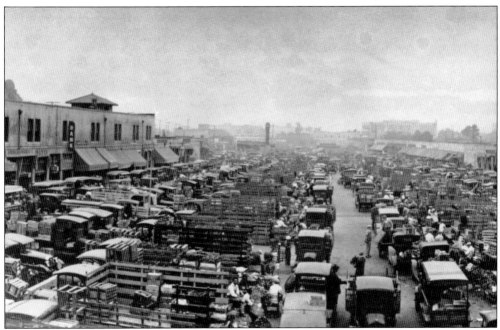

The success of Chinese Americans in the produce industry came to fruition with the establishment of the City Market at Ninth and San Pedro Streets. Founded in 1909 by city attorney Edward Fleming and Chinese American A. G. Jong, the City Market attracted proprietors and workers from all ethnic backgrounds who bought shares in the Market Company. This photograph was taken during the 1920s, when many Chinese began migrating out of Old Chinatown to establish a new enclave at Ninth and San Pedro Streets.

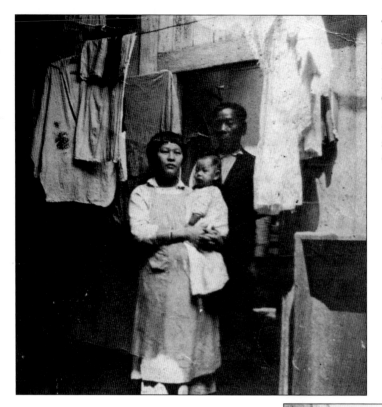

The Young family lived at 212 Ferguson Alley in Old Chinatown. In this 1923 photograph, Lung Bill Young and Chin Shee Young stand in the kitchen with their four-month-old son, Johnny. (Courtesy of John Young.)

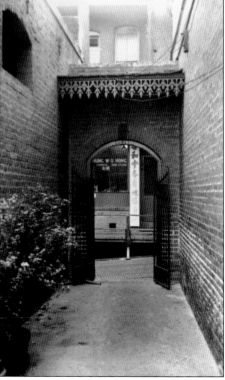

The Hung Wo Hong herbal store was located at 212 Ferguson Alley in Old Chinatown. The Young family lived behind the store, which served the community until 1945. (Courtesy of California Historical Society Title Insurance and Trust Photograph Collection, Department of Special Collections, University of Southern California.)

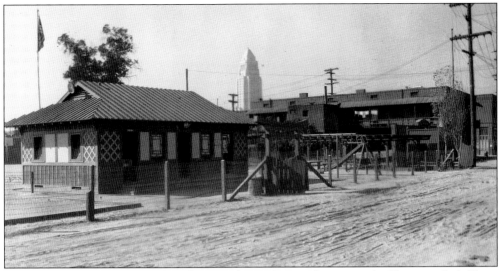

Pictured here in 1933, the Apablasa playground was a favorite destination for Chinatown's children. Before the 1920s, Old Chinatown did not have any parks or playgrounds. Teacher Margaret Cope from Macy Street Elementary School asked the Southern Pacific Railroad company for permission to convert a field next to unused stables into a playground. Since the field was full of trash and debris, Chinese children pooled their resources to rent a plow and horse to clean the area. (Courtesy of California Historical Society Title Insurance and Trust Photograph Collection, Department of Special Collections, University of Southern California.)

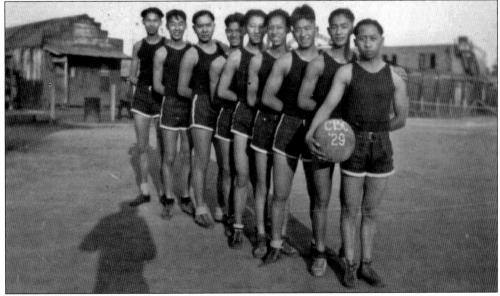

Sports provided a means of building community for second-generation youth in Old Chinatown. In the 1920s, a group of young men in Chinatown formed the LOWA (League of Western Athletes) basketball team. Pictured are, from left to right, George Tong, Faye Lee, Walter Lee, unidentified, Ted Yung, Chan ?, Ken Ung, and Taft Chung. Walter Lee lived with his family on Alameda Street in Old Chinatown and later served in the Merchant Marine during World War II. His father, Lee Thing, ran Leland's Men's Furnishings in Old Chinatown and also served as an interpreter for the U.S. Immigration Service. (Courtesy of Chris Lee and Pamela Wong.)

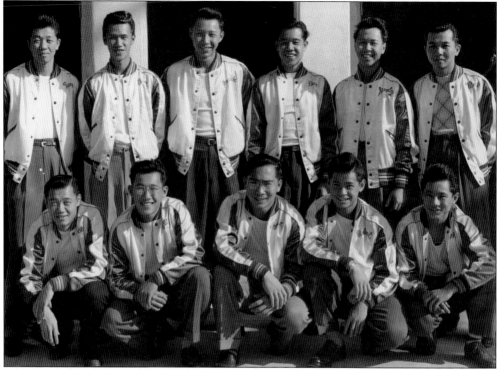

Early baseball teams in Chinatown could only afford used or discarded equipment from other teams. Cracked bats were nailed or taped together by children who loved baseball. Eventually, Chinatown's sports teams attracted sponsors who helped them purchase equipment and uniforms. However, many athletes experienced discrimination from spectators who yelled racial slurs during games. Chinatown's Cathay and Wah Kue ("overseas Chinese") teams gradually proved themselves to audiences, who by 1930 were applauding their sportsmanship.

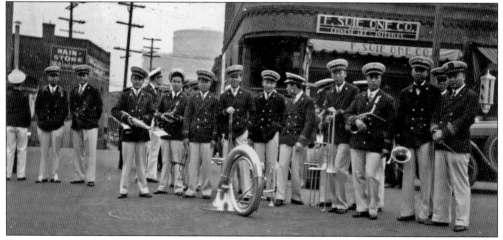

Second-generation Chinese Americans expressed their love of music through groups such as the Chinese American Citizens Alliance band. The CACA band was organized in the 1930s under the direction of Peter SooHoo Sr., pictured at the far right. The CACA band takes a break from a performance on Los Angeles Street in Old Chinatown. (Courtesy of the Peter SooHoo Sr. Collection.)

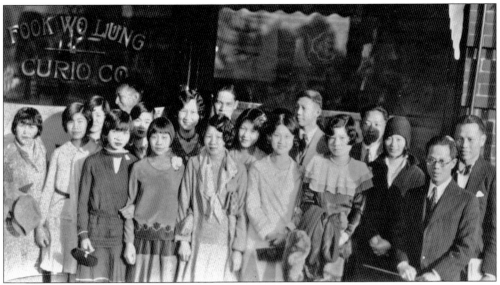

The University of Southern California Chinese Club visits the Fook Wo Lung Curio Company in Old Chinatown. The upward mobility of Chinese American parents during the 1920s allowed a growing number of them to send their children to college. (Courtesy of Leslee See Leong.)

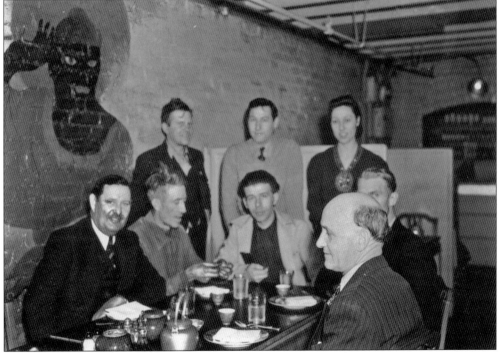

With a little help from his family and friends, Eddy See opened Dragon's Den restaurant on February 1, 1935. It was located in the basement of the F. Suie One Company, a store owned by his father, Fong See. The restaurant was immediately popular among celebrities and hipsters, who were attracted by its family-style dinners and artsy location in the downstairs den. The wall murals were painted by artists Benji Okubo and Tyrus Wong. Dragon's Den was eventually demolished to make way for the Hollywood Freeway. (Courtesy of Leslee See Leong.)

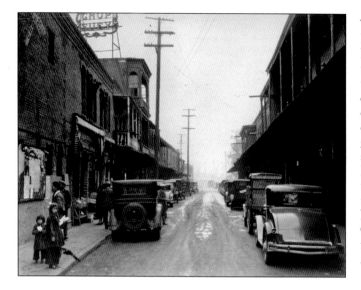

The Public Works Department of the City of Los Angeles documented the areas in Old Chinatown that were scheduled to be demolished. This block of Marchessault Street consisted of herbal and general stores, restaurants, and various associations. Man Jen Low restaurant is the three-story building on the left, which by the 1920s had installed its trademark Chop Suey sign on the roof. (Courtesy of the Los Angeles City Archives.)

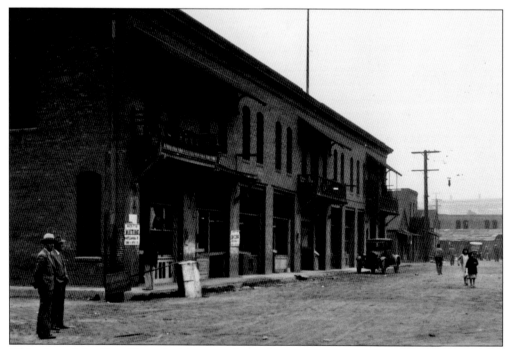

This view of Apablasa Street looking east shows the eviction notices posted by Whiting-Mead, which was contracted to handle the demolition of Old Chinatown. The razing commenced on the morning of December 23, 1933. The first to go was the left building at 401 Apablasa Street, indicated by the handwritten "Chinese school here" on the sidewall. (Courtesy of the Los Angeles City Archives.)

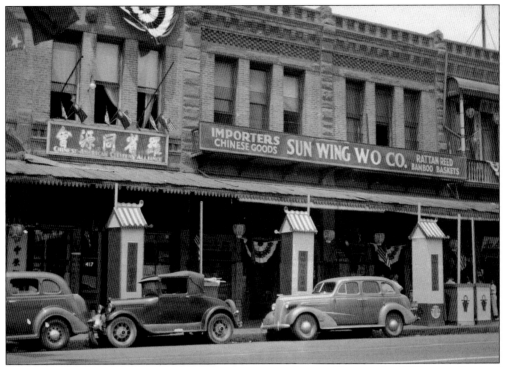

Not all of Old Chinatown was targeted for destruction. Pictured here in the 1930s, two-thirds of the Garnier Block on Los Angeles Street was spared by the city. This included the Sun Wing Wo store, which became the subject of a preservation effort by the Chinese American Museum in the 1990s. The store's interior was re-created in a permanent installation at the museum, which is located between Los Angeles Street and Sanchez Alley. (Courtesy of Peter SooHoo Sr.)

Thirteen-year-old Albert Lew boarded the SS *President Hoover* in Hong Kong and landed at the Port of San Pedro in 1937. He lived and worked at the Sun Wing Wo store in Old Chinatown for six months before moving to San Francisco to join his other relatives. After the Chinese American Museum opened in 2003, Lew became a regular volunteer who gave monthly talks about his experiences in Old Chinatown. (Courtesy of Albert Lew.)

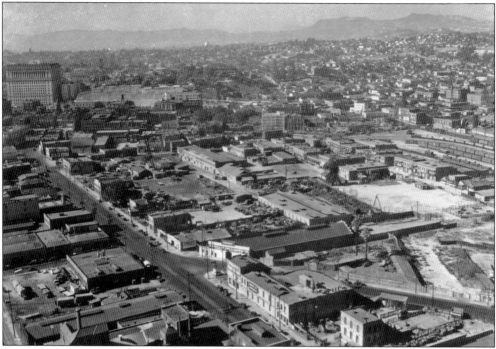

The above picture shows Old Chinatown before it was torn down to make way for Union Station in December 1933. Displaced residents left many items behind as they scattered to Ninth and San Pedro Streets, East Adams Boulevard, or other locations. (Courtesy of the Los Angeles City Archives.)

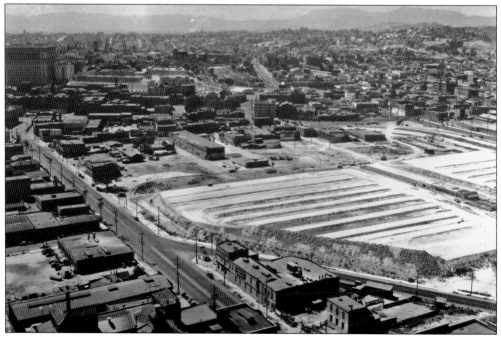

By 1935, the Chinese enclave east of Alameda was entirely razed and construction of the new Union Passenger Terminal began on this empty lot. (Courtesy of the Los Angeles City Archives.)

Two

NEW CHINATOWN, CHINA CITY, AND WORLD WAR II

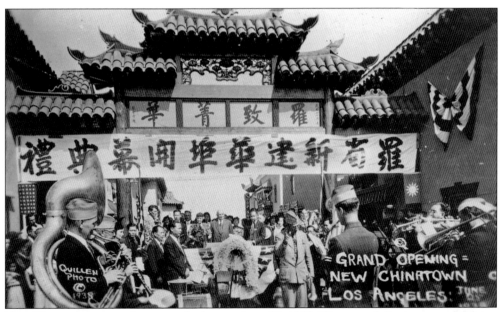

New Chinatown opened to great fanfare on June 25, 1938. Throngs of dignitaries, celebrities, and members of the community crowded Central Plaza to celebrate the opening of the first Chinese-owned enclave in the United States. The band played in front of the West Gate that faces Castelar Street (now Hill Street). Chinese consul T. K. Chang wrote the four-character inscription at the top of the gate, which meant, "Gathering the best (of Los Angeles)" and was translated by the founding members as "cooperate to achieve." Part of the gate was made of 150-year-old camphor wood.

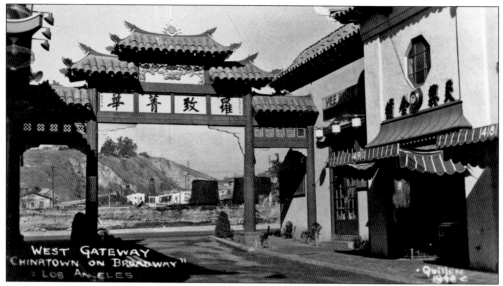

The open-air Central Plaza was designed to promote a family atmosphere, where several generations could find something to enjoy. Each street in the plaza had a specific meaning. Gin Ling Way was named after the Street of Golden Treasures in Beijing. Jung Jing Road refers to Chiang Kai-Shek, then president of the Republic of China. Mei Ling Way was named after his wife, Madame Chiang Kai-Shek. Sun Mun Way honors Dr. Sun Yat-Sen, founder of the Republic of China. The name Lei Min Way refers to Herbert Lapham, whose connection to the Santa Fe Railway allowed the Chinese to build New Chinatown.

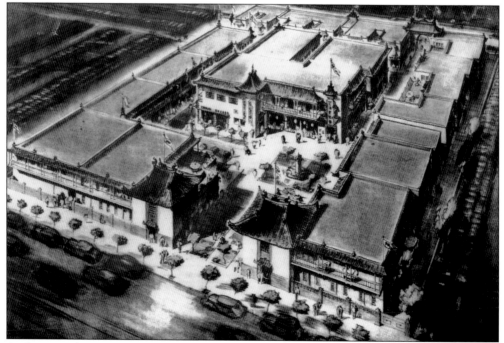

Architects Erle Webster and Adrian Wilson were hired to design the open-air Central Plaza in New Chinatown. Their design reflects the influence of traditional Chinese architecture, especially that of the Forbidden City in Beijing. (Courtesy of UCLA.)

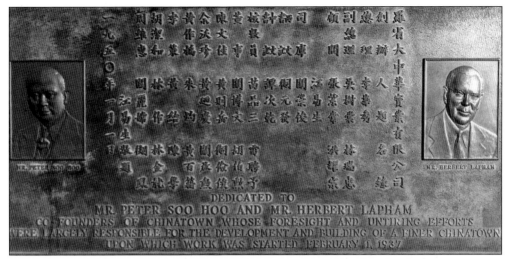

DEDICATED TO
MR. PETER SOO HOO AND MR. HERBERT LAPHAM
CO-FOUNDERS OF CHINATOWN WHOSE FORESIGHT AND UNTIRING EFFORTS
WERE LARGELY RESPONSIBLE FOR THE DEVELOPMENT AND BUILDING OF A FINER CHINATOWN
UPON WHICH WORK WAS STARTED FEBRUARY 1, 1937

Located in Central Plaza, the plaque above commemorates the collaboration between Peter SooHoo Sr. and Herbert Lapham, who was a land agent for the Santa Fe Railway and a supporter of the Chinese American community. At right, the names of the founding members and business owners are translated in English. (Both, courtesy of the Peter SooHoo Sr. Collection.)

The Founders
of
Los Angeles Chinatown

Los Angeles Chinatown Co-founders:
Mr. Peter SooHoo and Mr. Herbert Lapham

President	**Wah Siu Lee**
Vice-Presidents	**Walter Yip and John Lim**
Advisors	**T.K. Chang, Y.C. Hong and Y.S. Kiang**
Treasurer	**Quon Soon Doon**
English Secretary	**Peter SooHoo**
Chinese Secretary	**Tom H. Ling**
Auditors	**Mu Bien Sam and Ping Yuen Louie**

Dan Hall	**Woo Fon Lee**
Chen Man Gai	**Norman Wong**
Kim Doon Soo Hoo	**Eugene Yee**
Wong Na Hin	**Him Gin Quon**
Wong Do Guei	**Jack Gee**
Dick Wong	**Lei Chei**
George Wong	**Charlie Chan**
Woo Get Wo	**Lim Dou**
Lum Gim Du	**Edwin On Chow**
Marjorie Quon	**Lucille SooHoo**

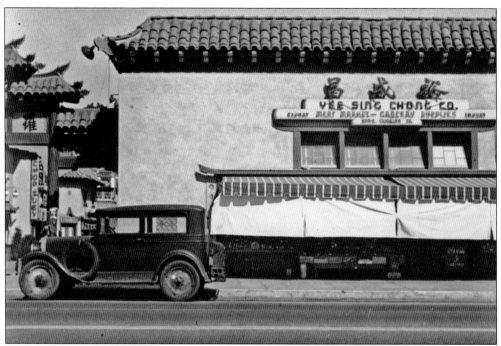

Lee Wah Siu opened a new location of the Yee Sing Chong Company at 966–970 North Hill Street (formerly Castelar Street) in New Chinatown. It had moved from 305 Marchessault Street in Old Chinatown. Yee Sing Chong was a popular Chinese supermarket that attracted customers from all over Southern California. The business was purchased by Jack Lee, who later opened First Public Savings Bank, Bamboo Plaza, and Empress Pavilion restaurant in New Chinatown.

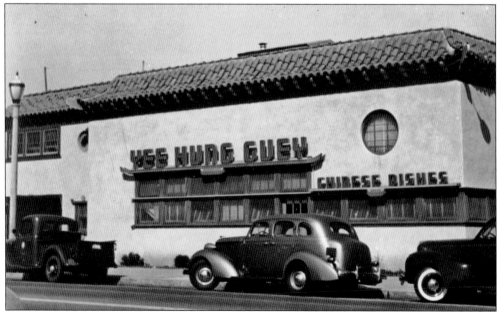

Founded by Jack Gee, Yee Hung Guey restaurant was located on the north side of the West Gate in Central Plaza. During World War II, the restaurant was among the busiest in Chinatown, and lines extended down the sidewalk. It is currently the site of Chong Hing Jewelers.

In 1938, Man Jen Low opened its new location at 475 Gin Ling Way in Central Plaza. Owner Fon Lee (Woo Fon Lee) met with Peter SooHoo Sr. in 1934 to discuss moving his restaurant from Marchessault Street in Old Chinatown. Construction began in 1937, and the building was ready for business on the opening day of New Chinatown. In 1954, the name was changed to General Lee's to attract more customers.

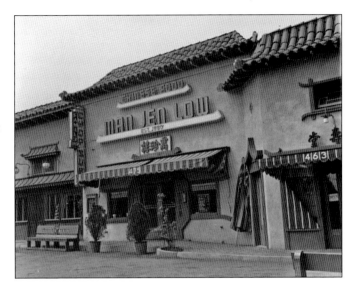

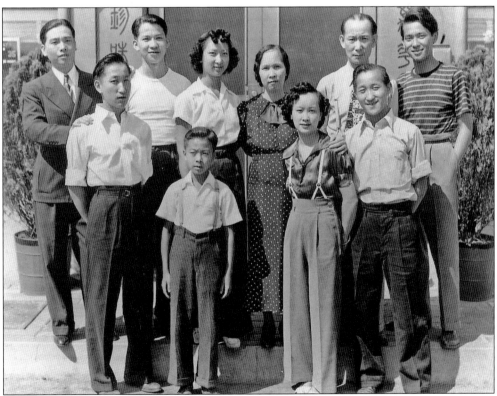

Pictured in front of Man Jen Low in the early 1940s, the Lee family continued to run the restaurant until it closed down in 1985. From left to right are (first row) Norman Lee, Joe Lee, Rose Lee, and Merton Lee; (second row) Kau Lee, David Lee, Jenny Lee, Lum Shee, Fon Lee (Woo Fon Lee), and Walter Lee. (Courtesy of David Lee.)

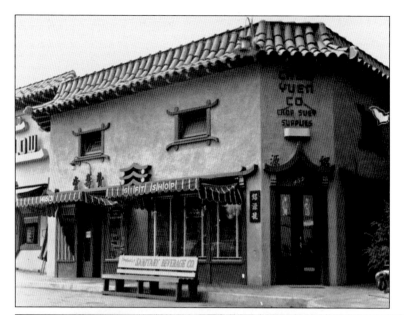

Chew Yuen Company was one of the first businesses in Central Plaza. Owner She Wing SooHoo moved the store from its previous location at 308 Marchessault Street in Old Chinatown to its new address at 459 Gin Ling Way.

The SooHoo family lived and worked at Chew Yuen Company in Old and New Chinatown. This picture was taken around 1941 in front of Chinese Jade restaurant in Central Plaza. From left to right are (first row) Walter, Hayward, Betty, and Howard SooHoo; (second row) Philip, baby Eunice, Woo Shee, She Wing, and Willie SooHoo. Not pictured is Roland SooHoo. (Courtesy of the Shades of L.A. Archives/Los Angeles Public Library.)

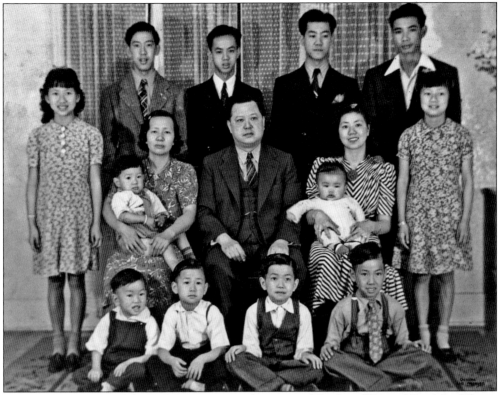

Ping Yuen Louie opened the K. G. Louie store at the corner of Gin Ling Way and Sun Mun Way in Central Plaza. It is still managed by his family to this day. From left to right are (first row) William, Eugene, Raymond, and Hoover Louie; (second row) Lee Shee Louie holding Ronald, Ping Yuen Louie, Betty Jowe holding Linda, and Edna Louie; (third row) Virginia Louie, Henry Louie, Jimmy Louie, Quan Louie, and Chuck Jowe. (Courtesy of Hoover Louie, son of Ping Yuen Louie.)

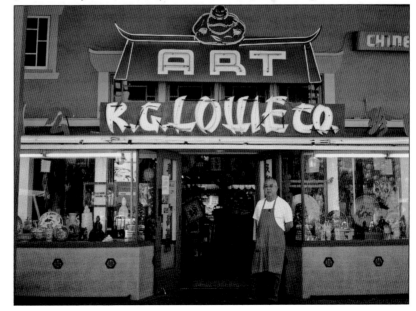

Along with other members of his family, William Louie continues his father's legacy by working at the K. G. Louie store every week.

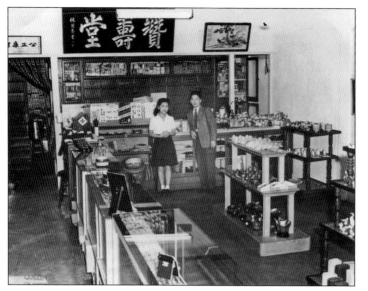

Owner Mu Ben-Sun opened the Don Shew Hong store on Marchessault Street in Old Chinatown and lived with his family in a two-room apartment next to Man Jen Low restaurant. After the street was torn down to build Union Station, Mu relocated the store to Gin Ling Way in New Chinatown. Pictured here are Lilly and George Mu, who worked in the family business, which was renamed Mu Brothers after World War II.

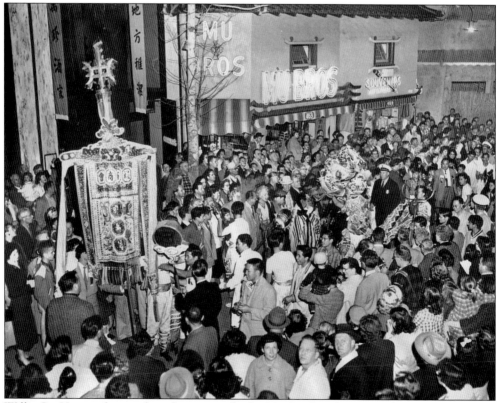

Willie SooHoo performs a lion dance outside the Mu Brothers store on Chinese New Year in 1958. (Courtesy of the Shades of L.A. Archives/Los Angeles Public Library.)

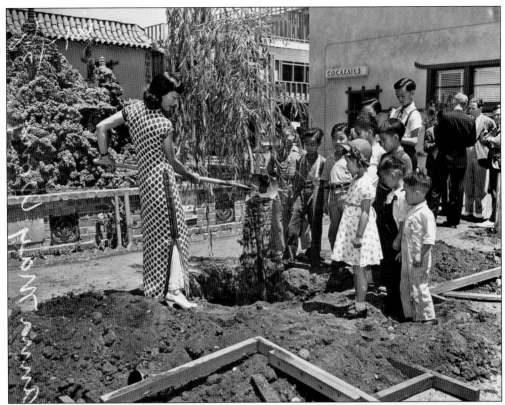

During the 1930s and 1940s, Anna May Wong was the most famous Chinese American actress in Hollywood. She planted a willow tree in front of the Wishing Well, which was built by professor and artist Liu Hong Kay from a design inspired by the Seven Star Caverns in Canton, China. (Courtesy of UCLA.)

Founded by Fong Kin Chin, Sincere Imports began as a 10-by-10-foot booth and then eventually relocated to Gin Ling Way in Central Plaza. The store is one of the oldest businesses in Chinatown and continues to operate to this day.

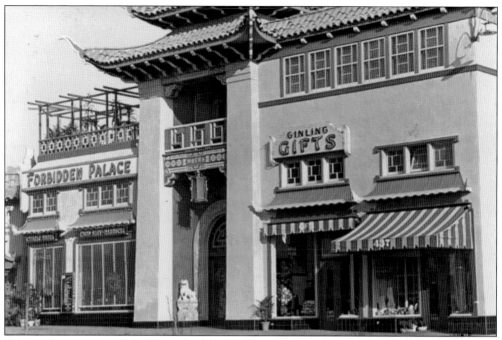

Prior to the opening of the Hong building in Central Plaza, attorney Y. C. Hong's office was located at 741½ North Alameda Street. Hong hired architects Adrian Wilson and Erle Webster to design his new building, located at 437–451 Ginling Way. The building housed businesses such as Ginling Gifts, Kwan Yuen Company, and Forbidden Palace restaurant. Hong was the first Chinese American to graduate from the University of Southern California law school and the first Chinese American to practice law in Los Angeles.

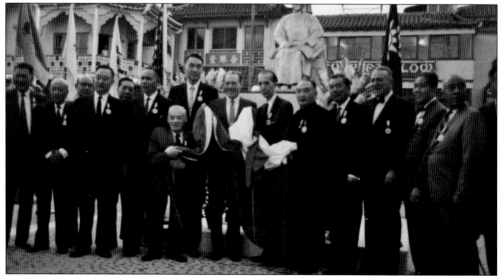

Holding the left part of the flag, attorney Y. C. Hong stands with members of the Chinese American Citizens Alliance in front of the statue of Sun Yat-Sen, which was dedicated in Central Plaza in 1966. Hong was a pioneering attorney and leader in the Chinese community who fought for the repeal of the Chinese Exclusion Act and helped thousands of clients navigate the legal system. He worked tirelessly on behalf of Chinese American civil rights until his death in 1977.

Located in the Hong Building, Ginling Gifts was owned by Peter SooHoo Sr., cofounder of New Chinatown. Standing in the middle is Edith Tom, an employee who began working at the store after she graduated from the Metropolitan School of Business. To the left is SooHoo's coworker from the Department of Water and Power who also helped out at the store. (Courtesy of the Peter SooHoo Sr. Collection.)

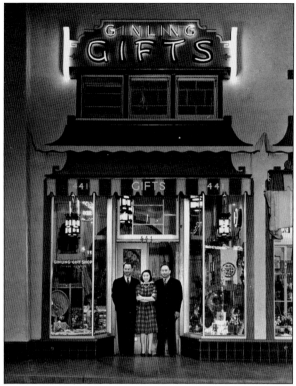

Kwan Yuen Company was a gift store located at 437 Gin Ling Way in the Hong Building. The undeveloped landscape of the north end of Chinatown is visible through the windows.

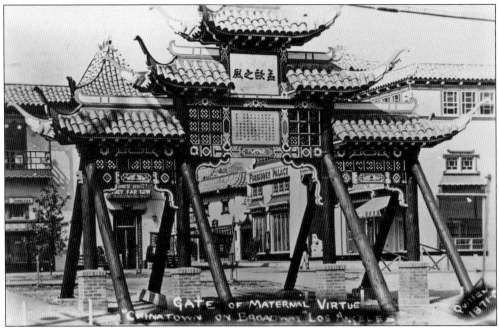

The Gate of Maternal Virtue, also known as the Gate of Filial Piety, was built by Y. C. Hong as a tribute to his mother and to all mothers. Originally made of century-old camphor wood, the gate is located on the east side of Central Plaza that faces North Broadway Street.

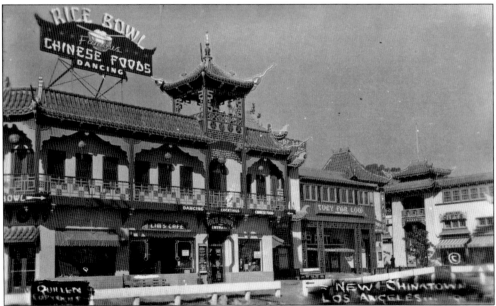

The Rice Bowl restaurant and nightclub was located on Sun Mun Way and featured regular floor shows and musical performances. In the 1970s and 1980s, the space was occupied by Madame Wong's, a nightclub that was a popular venue for local and international rock bands. By 2008, the second floor was transformed into private residences.

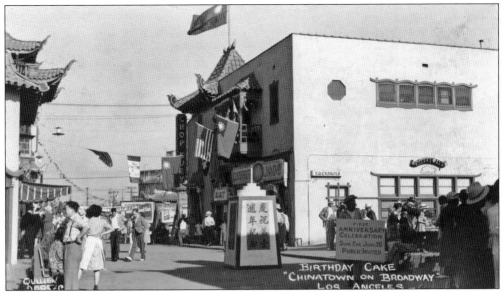

New Chinatown celebrated its first anniversary on June 25, 1939. A man holds a sign that invites the public to participate in the upcoming festivities.

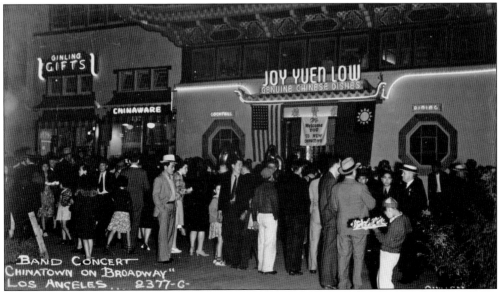

Located at 425 Gin Ling Way, the Joy Yuen Low restaurant was completed in April 1940 at a cost of $65,000. Built for a capacity of 250 persons, the restaurant featured a design that combined a mixture of traditional Chinese architecture and modern aesthetics.

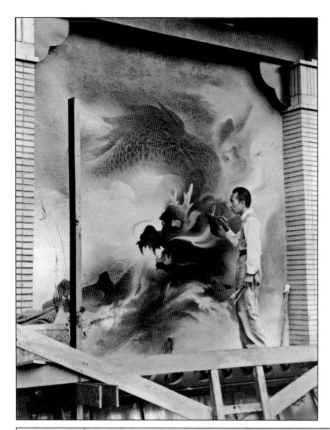

Artist Tyrus Wong painted the *Chinese Celestial Dragon* mural in New Chinatown's Central Plaza in 1941. After immigrating to the United States from Toishan, China, Wong and his father lived in Old Chinatown's Ferguson Alley. His artistic talent was recognized by his junior high school instructor, who encouraged him to apply to Otis Art Institute. His father and the Chinese community raised funds to pay for his tuition. Wong graduated at the top of his class and became one of the first Chinese Americans employed by Walt Disney Studios. The bottom picture indicates the location of Wong's mural, to the right of South China Gifts and Phoenix Bakery. The mural was restored in 1984 by artist Fu Ding Cheng. (Above, courtesy of the Security Pacific Collection/ Los Angeles Public Library.)

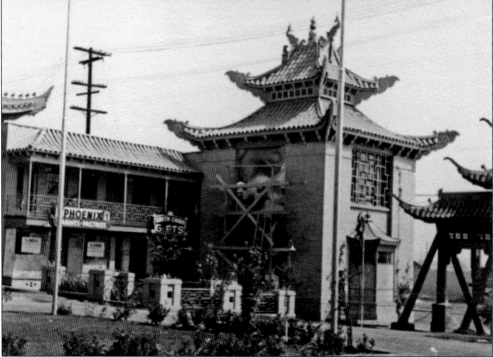

Phoenix Bakery was established in 1938 by Fung Chow Chan and his wife, Wai Hing. Chan also became one of the first presidents of the Los Angeles Chinese Chamber of Commerce and the founder of two banks—East West Bank and Cathay Bank. Pictured from left to right in 1942 are (first row) Au Young Shee, Kellogg Chan, and Chung Yat Chan; (second row) Chai F. Chan, Fung Chee, Kathy Chan, Wai Hing, Fung Chow Chan, and Lun F. Chan. (Courtesy of Kellogg Chan.)

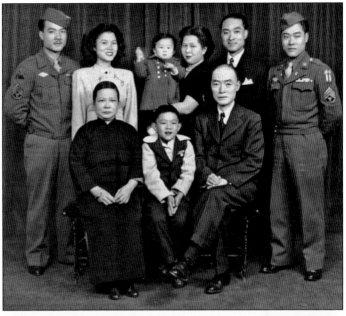

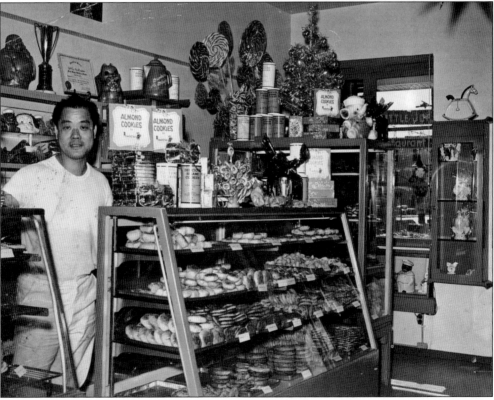

When Lun F. Chan (brother of founder Fung Chow Chan) joined Phoenix Bakery in 1941, he developed the recipe for its trademark fresh strawberry whipped cream cake. Lun F. Chan stands behind a case of the bakery's handmade almond cookies, sticky sugar butterflies, puff pastries, tarts, and more. (Courtesy of Lun F. Chan.)

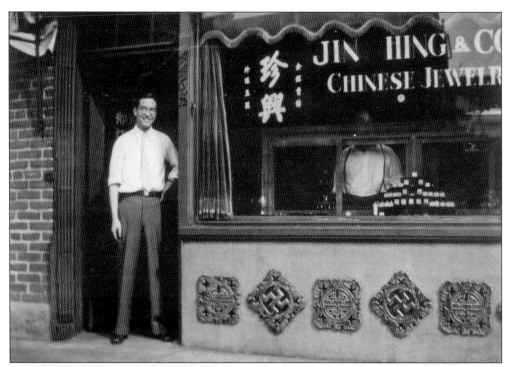

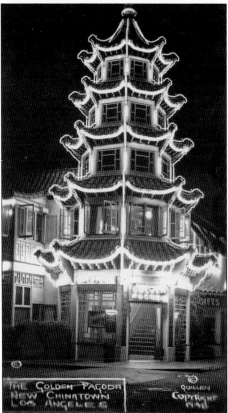

Leon Lee (above, left) and his father, Lee King Yee (above, right), founded Jin Hing Jewelry during the Great Depression in 1933. Pictured here, the original store was located at 446½ Los Angeles Street. The business moved to its current location at 412 Bamboo Lane in 1950. (Courtesy of Robert Lee.)

Founded by Dan Hall and other partners, the Golden Pagoda restaurant became a popular landmark for New Chinatown after its opening in 1941. Later managed by Chester Quon, the restaurant switched ownership in 1985 and was renamed Hop Louie by its new owner, Walter SooHoo. SooHoo's family previously operated the Chew Yuen Company store on Gin Ling Way.

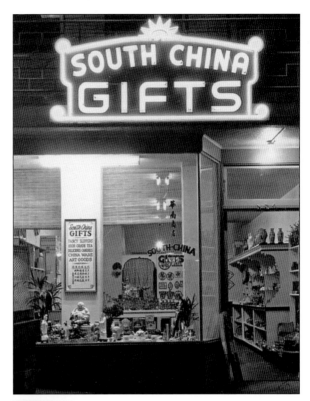

Pictured with his three grandchildren (shown below), Sung Soo-Hoo opened South China Gifts at 407 Gin Ling Way, at the corner space between Phoenix Bakery and Li Po Restaurant. The family lived in the back of the store until Soo-Hoo moved to a new space on Chung King Road across Hill Street. (Right, courtesy of the Security Pacific Collection/ Los Angeles Public Library; below, courtesy of Al Soo-Hoo.)

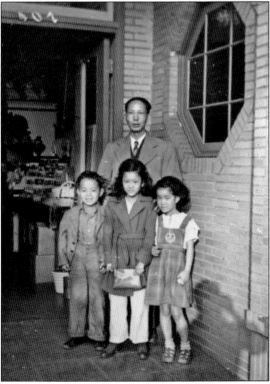

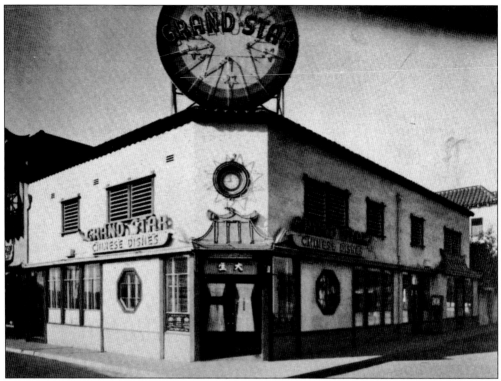

Grand Star restaurant was opened by brothers Frank and Wallace Quon after opening in 1946. Their grandfather, Quon Soon Doon, was a cofounder of New Chinatown and owner of Tuey Far Low, which was first established in Old Chinatown. Construction on Grand Star had begun in 1941, but the opening was delayed by World War II. The restaurant was a popular bar and nightclub for celebrities and clientele who stopped in after working downtown. (Courtesy of Wallace Quon.)

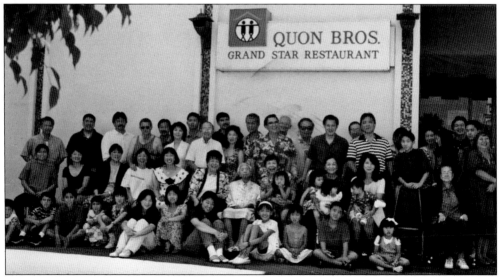

The Quon family held a family reunion in 1994. Matriarch Mama Quon sits in the center of her large family. (Courtesy of Wallace Quon.)

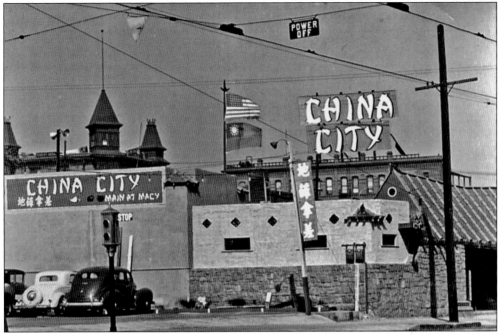

China City was a tourist attraction developed by socialite Christine Sterling, whose ties to Harry Chandler of the *Los Angeles Times* enabled her to generate support for the project. Bounded by Main, Ord, Spring, and Macy Streets, this "second Chinatown" opened in 1938 and became home to a community of Chinese business owners and families. (Courtesy of the Shades of L.A. Archives/Los Angeles Public Library.)

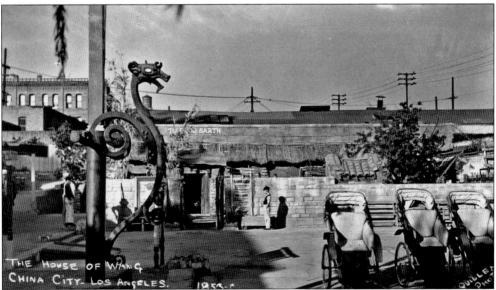

The design of China City featured movie sets from *The Good Earth*, a film adapted from the novel by Pearl S. Buck. The House of Wang set is featured in this 1940 photograph. Chinatown residents sometimes played background Hollywood films. (Courtesy of the Security Pacific Collection/Los Angeles Public Library.)

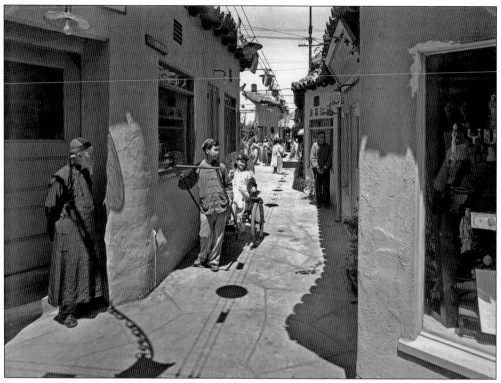

By 1940, China City consisted of narrow, mysterious alleys that contrasted with the design of the open-air Central Plaza in New Chinatown. Johnny Yee carries a passenger on his rickshaw. (Courtesy of the Huntington Library.)

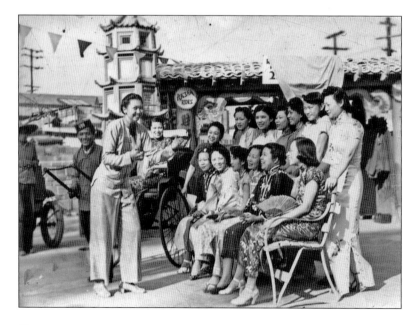

China City also had its own pagoda, which housed the Lotus Inn restaurant. Pictured to the left in 1939, Dorothy Siu of the Flower Hut stands next to her regularly costumed friends, who were always ready to invite visitors for a 25¢ rickshaw ride around China City. (Courtesy of Ruby Ling Louie.)

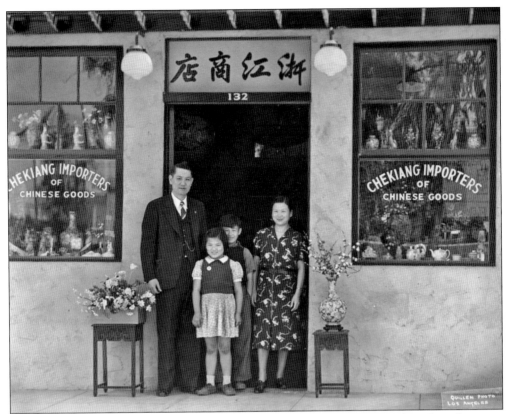

浙江商店

132

CHEKIANG IMPORTERS OF CHINESE GOODS

CHEKIANG IMPORTERS OF CHINESE GOODS

Chekiang Importers was one of three shops that sold scholars stone-carved artifacts that were made by villagers in China. Pictured are the entrepreneur owner Tsin Nan Ling, his children Ruby and Joe, and wife, Poo Tsui Ling. (Courtesy of Ruby Ling Louie.)

Wong-A-Loo's Chinese Hut was among a number of fine dining restaurants in China City that promoted family dinners for as little as 50¢. To the left is photographer Harry Quillen, whose pictures provided a valuable historical record of the Chinese American community in Los Angeles. (Courtesy of the Security Pacific Collection/ Los Angeles Public Library.)

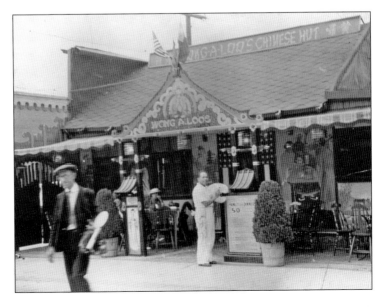

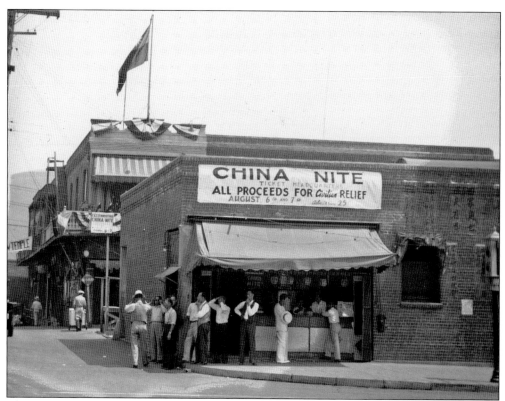

China Nite was a two-day festival organized by the Chinese Consolidated Benevolent Association to raise funds for the war relief effort in China. Tickets were 25¢ to the event held on August 6 and 7, 1938. (Courtesy of the Peter SooHoo Sr. Collection.)

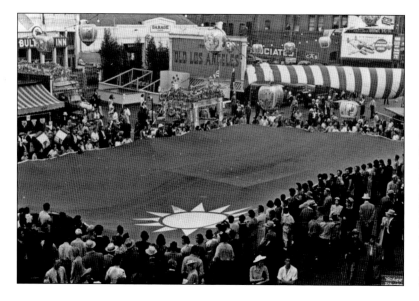

Crowds threw money into this oversized Chinese flag on Los Angeles Street to raise funds for the war effort. (Courtesy of the Peter SooHoo Sr. Collection.)

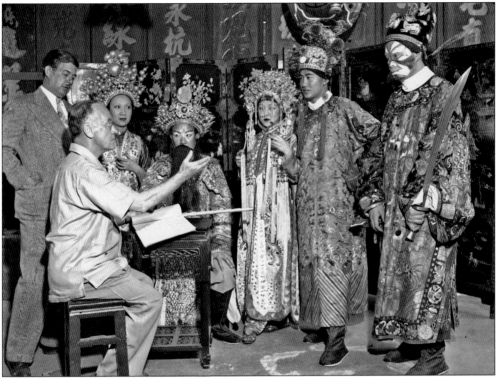

Seated to the left in 1939, Tom Gubbins was a casting agent who recruited many Chinese Americans to work as extras in Hollywood films. He also directed Chinese operas and cultural programs to entertain China City visitors. Pictured second from right is actor Roland Gott, who later committed suicide. (Courtesy of UCLA.)

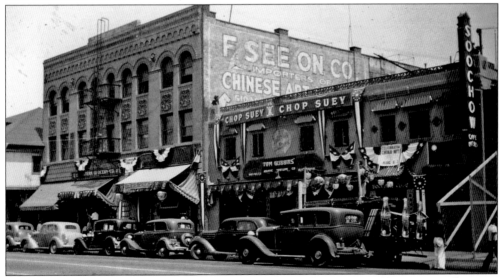

The Tom Gubbins Asiatic Costume Company was located on Los Angeles Street, in between Eastern Grocery and the F. See On Company. Soochow Restaurant, owned by the Leong family, was located on the far right. The block is draped in decorations to celebrate China Nite on August 6 and 7, 1938. (Courtesy of the Peter SooHoo Sr. Collection.)

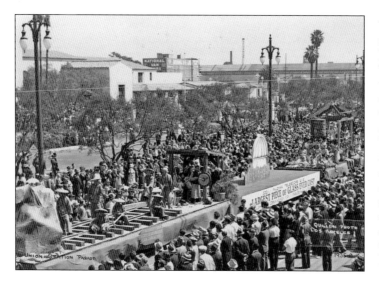

The Union Station opening-day parade was held on May 3, 1939. This float acknowledges the contributions of Chinese railroad workers. Although displaced by the building of Union Station, members of the Chinatown community attended and participated in the celebration. (Courtesy of the Security Pacific Collection/Los Angeles Public Library.)

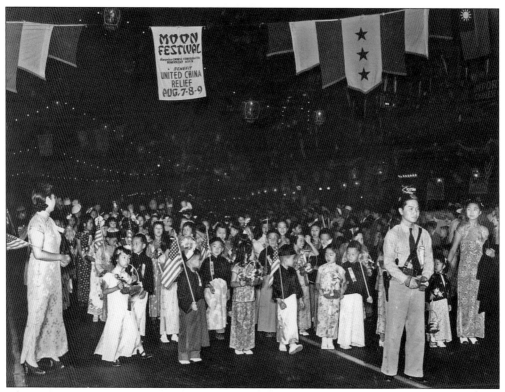

The 1941 Moon Festival was a three-day celebration that attracted over 30,000 people to New Chinatown on August 7, 8, and 9. Sponsored by the Chinese Consolidated Benevolent Association, the festival raised funds for United China Relief, an agency that sent urgently needed supplies to Chinese refugees during World War II. The Children's Flower Corps marched in the parade on the third day of the festival. (Courtesy of the Peter SooHoo Sr. Collection.)

As queen of the Moon Festival, Margaret Kwong rode on this float during the parade. In the foreground are three members of her court, including Doris May seated behind the front swan. (Courtesy of Margaret Kwong.)

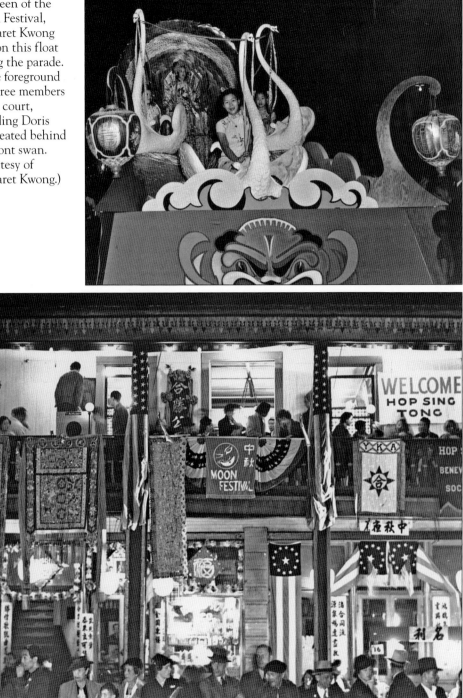

Hop Sing Tong opened its doors to the public during the Moon Festival. The organization was originally located in the Lugo House in Old Chinatown before the structure was torn down for Hollywood Freeway access improvements. (Courtesy of the Security Pacific Collection/Los Angeles Public Library.)

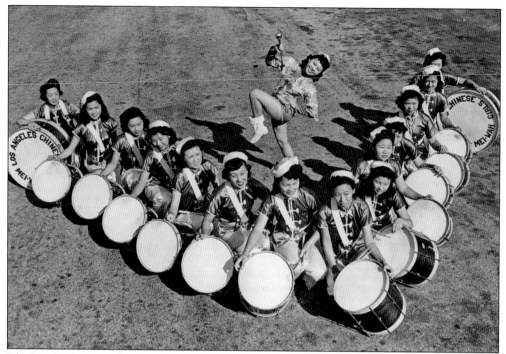

The Mei Wah Drum Corps poses in a victory "vee" formation in preparation for the 1941 Moon Festival. Pictured from left to right are Margaret Kwong, May Yoke Louie, Bernice Soohoo, Anna Chew, Cleo Chow, Jackie Ung, Dora Soohoo, Betty Chow, Ada Chew, Kaza Quan, Dorothy Lew, Marcella Yip, Mamie Lee, and Doris May Young. Barbara Jean Wong Lee kicks up her heel behind them. (Courtesy of the Peter SooHoo Sr. Collection.)

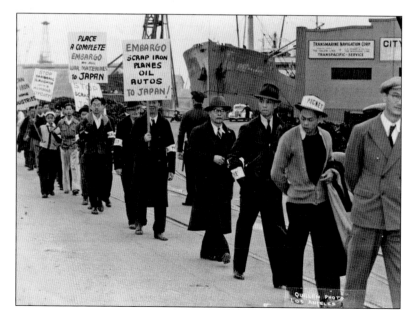

After the invasion of China by Japan, members of the Chinatown community joined a protest in Long Beach on January 19, 1938, to call for a boycott against the sale of scrap iron to Japan. (Courtesy of the Security Pacific Collection/ Los Angeles Public Library.)

Howard Yip wore this sign at work to protect himself against discrimination during World War II. (Courtesy of the Los Angeles Examiner and California Historical Society Title Insurance and Trust Photograph Collection, Department of Special Collections, University of Southern California.)

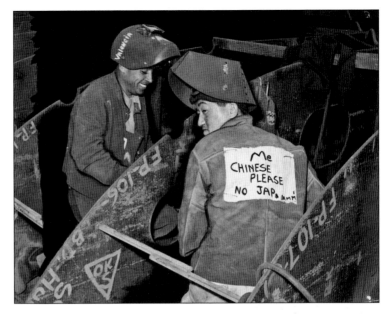

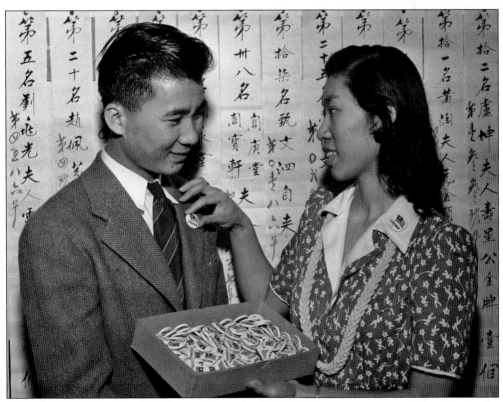

After the bombing of Pearl Harbor on December 7, 1941, Asians were a target of hostility in the United States. In Los Angeles, the Chinese Consolidated Benevolent Association sold 4,000 "China" buttons to Chinese Americans. CCBA secretary Helen Chan pins a "China" button on the lapel of Sim Lam on December 21, 1941. (Courtesy of UCLA.)

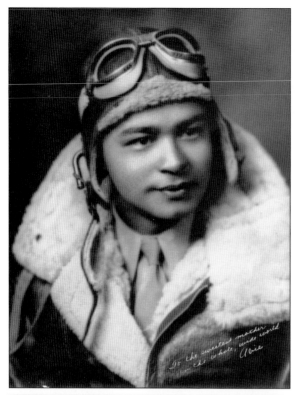

Abraham Chin was born in Old Chinatown and later moved to the East Adams neighborhood, where he cofounded the CFO gas station with his brothers and friends. As the child of a Chinese father and African American mother, Chin was sent to train with the Tuskegee Air Force in 1944. More than 13,000 Chinese Americans were drafted by the military during World War II. Around 1,200 served in all-Chinese American units, while the majority were placed in integrated units. Chinese Americans volunteered and enlisted out of a sense of duty to their country. As a result of their contributions to the war effort, the image and social status of Chinese Americans improved dramatically. (Courtesy of the Chin family.)

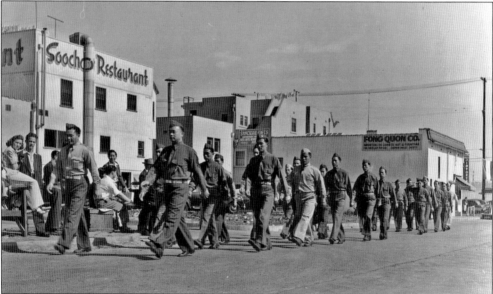

During World War II, the California State Militia Chinese Reserve was formed by Chinese American men in Los Angeles to demonstrate their patriotism in the face of anti-Asian sentiment throughout the city. Also known as the Los Angeles Chinatown militia unit, this special company received a license to drill and bear arms from Gov. Cullen Olson on April 25, 1942. The unit marched regularly throughout Los Angeles, including here in Old Chinatown. (Courtesy of the Peter SooHoo Sr. Collection.)

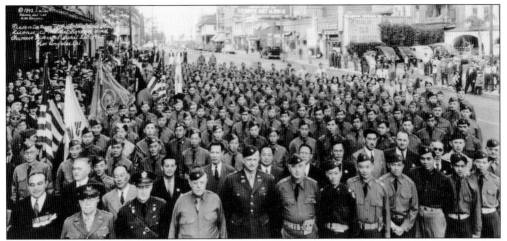

The presentation of the colors and state license to the Chinese, Filipino, and Korean units of the National Guard was held in 1942. This photograph was taken on Los Angeles Street in Old Chinatown, with the Lugo House, F. See On Company, and Jerry's Joynt visible in the background. Peter SooHoo Sr., cofounder of New Chinatown, is in the first row, fifth from right. (Courtesy of Korean American Digital Archive, University of Southern California.)

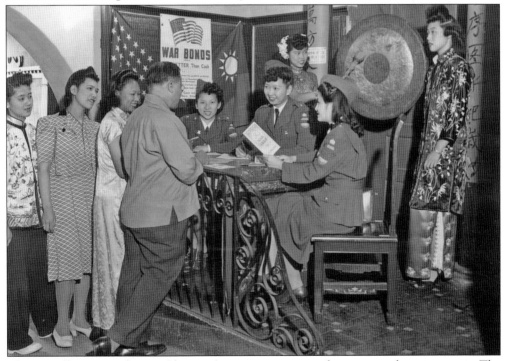

The war effort inspired many Chinese American women to demonstrate their patriotism. The Los Angeles Chinatown branch of the American Women's Voluntary Service (AWVS) raised funds and ran a canteen for servicemen in Chinatown. These women sold war bonds from a booth in China City on September 21, 1943. From left to right are Diana Got, Lillian Luck, Flora Yuen, bond buyer Harry King, Dorothy Lum, Dorothy Siu, and Vivian Chinn. Next to the gong are Choey Low (left) and Margaret Kwong. (Courtesy of the Herald Examiner Collection/ Los Angeles Public Library.)

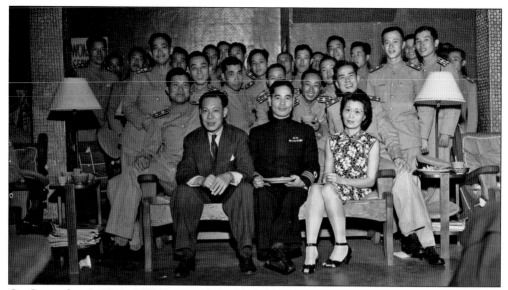

On September 9, 1944, AWVS opened the New Chinatown Canteen at Soochow Restaurant, owned by the Leong family. The canteen provided hospitality and home-cooking to military personnel from all over the country, as well as these air force cadets from China. AWVS records reveal that the canteen served an estimated 1,500 people per month. (Courtesy of UCLA.)

On February 19, 1942, Pres. Franklin Delano Roosevelt issued Executive Order 9066, which authorized the incarceration of over 120,000 Japanese Americans and individuals with Japanese ancestry into designated exclusion zones. Rather than be separated indefinitely, Johnny Young accompanied his wife, Kiyoko, to the Manzanar Relocation Center. Their daughter, Beverly, was born at Manzanar on March 19, 1943. After their release, the family moved to this two-bedroom house at 445½ Solano Street in 1943. This street was predominantly Italian American before gradually becoming absorbed into the New Chinatown community. (Courtesy of John Young.)

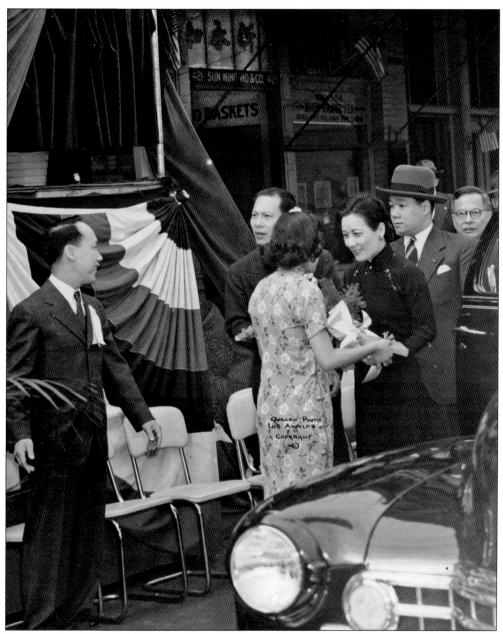

Madame Chiang Kai-Shek receives flowers in front of the Sun Wing Wo store at 421 Los Angeles Street. Standing beside her (from left to right) are banker Sou Jen Chu, Chinese consul T. K. Chang, L. K. K'ung, and Rev. K. N. Leong. In 1943, Madame Chiang embarked on a multi-city tour of the United States to raise support for China. During her visit to Los Angeles, she gave public speeches at Old Chinatown, Los Angeles City Hall, and the Hollywood Bowl. (Courtesy of the Library of Congress.)

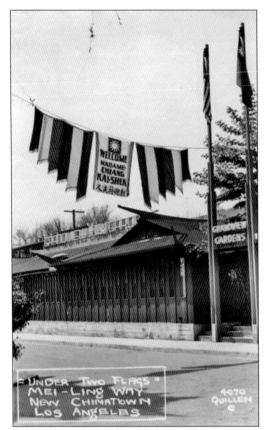

A banner in front of Grandview Gardens on Castelar Street (now Hill Street) welcomed Madame Chiang Kai-Shek to Los Angeles. Brothers Doc H. and Norman Wong purchased the land at 951 Mei Ling Way and hired architect Harwell Hamilton Harris to design the restaurant, which opened in 1940. In 1976, the restaurant was sold to a corporation that included brothers Irvin, Collin, and Milton Lai. It closed down in 1991. (Courtesy of the Security Pacific Collection/Los Angeles Public Library.)

The Los Angeles Chinese Women's New Life Movement Society and members of the American Women's Voluntary Service wait to hear a speech by Madame Chiang Kai-Shek in Old Chinatown during her visit in 1943. (Courtesy of the Security Pacific Collection/Los Angeles Public Library.)

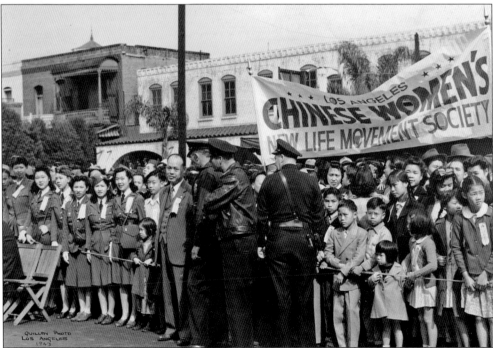

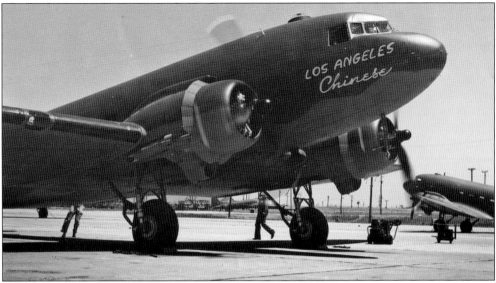

This air evacuation plane was named *Los Angeles Chinese*. The photograph was sent from the War Finance Committee to attorney Y. C. Hong on July 20, 1945. (Courtesy of the You Chung Hong and Mabel Chin Hong Archives.)

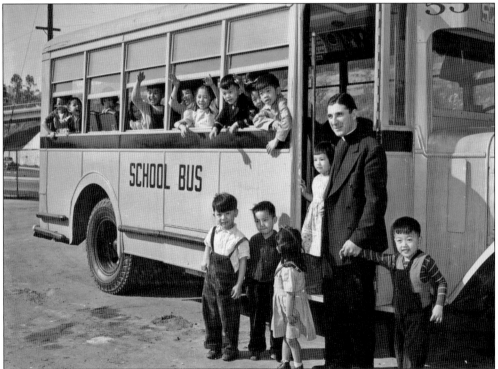

Under the leadership of Fr. John Cowhig, the original building of the St. Bridget's Catholic Chinese Center was constructed at 510 Cottage Home Street in 1940. Prior to opening the school, Father Cowhig had served as a missionary in China and was asked by Bishop Paul Yu Pin to start a Catholic mission in Los Angeles. Pictured here, Father Cowhig and his students celebrate the donation of a school bus in 1945.

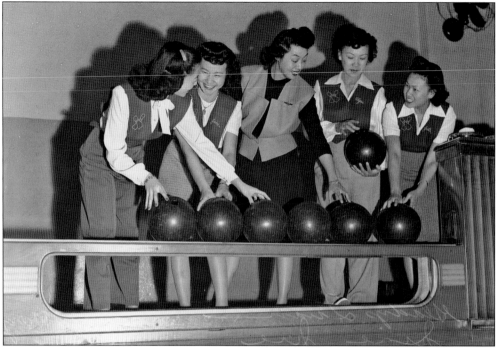

From left to right are Gladys Quan, June Jue, Margaret Kwong, Olga Wong, and Julie Wong as they enjoy a round of bowling on February 13, 1945. Prior to 1946, Chinese bowlers were not allowed to compete in any American Bowling Congress tournament. As a result, Chinese Americans formed leagues such as the Los Angeles Chinese Bowling Club, which competed in Chinese-sponsored tournaments in various cities. (Courtesy of UCLA.)

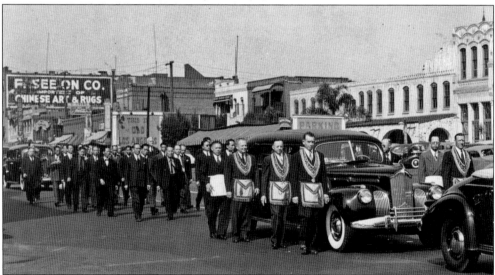

On April 20, 1945, Peter SooHoo Sr. collapsed at his home and was taken to the French Hospital, where he was pronounced dead from a cerebral hemorrhage. His funeral procession was a half-mile long and traveled through the streets of Chinatown en route from the Chinese Presbyterian Church in East Adams. Community members from Chinatown and beyond mourned his death, which, at the age of 44, came all too soon. (Courtesy of the Peter SooHoo Sr. Collection.)

Three

POSTWAR CHINATOWN

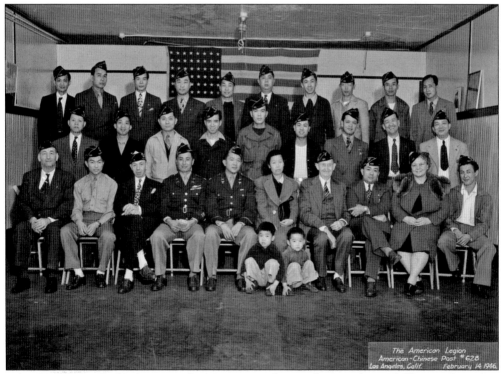

After World War II, the American Legion approved an application from 16 Chinese American veterans to open a post in Los Angeles. American Chinese Post 628 was granted a charter on September 21, 1945, and opened its first headquarters at 1014 South San Pedro Street. The post was an important resource for returning veterans, who utilized its immigration, legal, and health services. This photograph was taken on Valentine's Day, 1946. (Courtesy of American Legion, American Chinese Post 628, Los Angeles, California.)

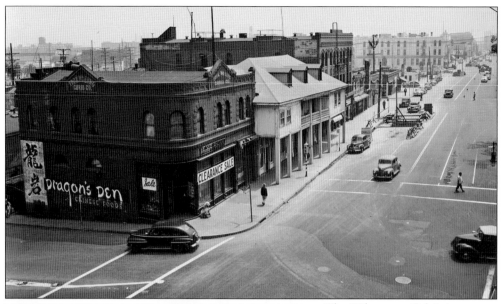

The "Clearance Sale" sign in the window of the F. Suie One Company portends the scheduled destruction of this block of Los Angeles Street for the building of ramps leading to the Hollywood Freeway. Chinese Americans lobbied the city council to protect the block and its businesses, but the freeway ultimately prevailed. Pictured here on June 27, 1949, the historic Lugo House, Kong Chow Temple, Dragon's Den, and other businesses on Los Angeles Street and Ferguson Alley are now just a memory. (Courtesy of UCLA.)

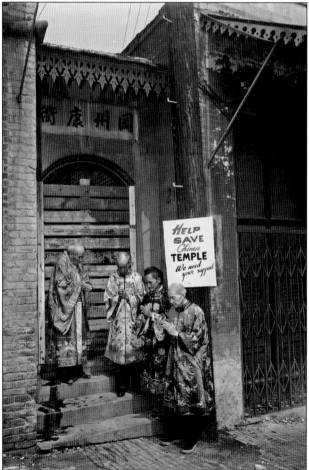

Chinese men pray outside the Kong Chow Temple in Ferguson Alley to save it from destruction. As seen to the right, Pagoda Bar had already closed down. This photograph from September 14, 1950, was one of the last taken of the structure before it was razed to build exit ramps for the Hollywood Freeway. (Courtesy of UCLA.)

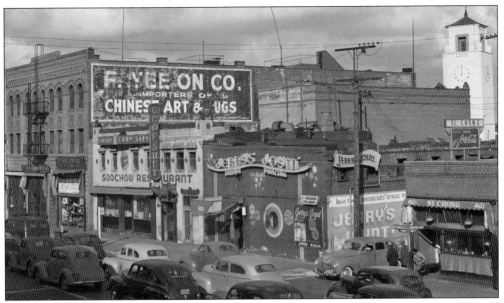

This block of Los Angeles Street in Old Chinatown shows Jerry's Joynt, Soochow restaurant, Si Chong, and the entrance to Ferguson Alley. Jerry's Joynt was a late-night restaurant and dance hall owned by G. H. Surprenant, who passed away in 1956. Soochow restaurant was owned by architect Gilbert Leong, who drafted plans for an International Settlement proposed by his brother-in-law, Eddy See. The plans called for a multicultural retail center that could save the businesses, but the Los Angeles City Council ultimately decided to proceed with the building of Hollywood Freeway access ramps. (Courtesy of UCLA.)

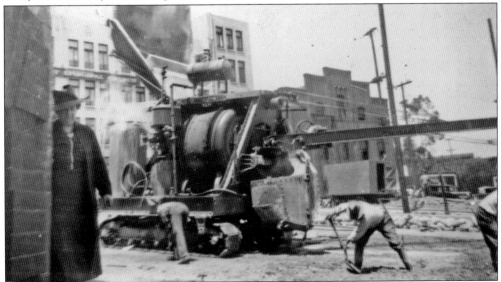

Letticie "Ticie" Pruett witnessed the demolition of the last block of Old Chinatown, which included Dragon's Den and Soochow restaurant. Dragon's Den was owned by her son, Eddy See; Soochow was owned by her son-in-law, Gilbert Leong. See and Leong worked tirelessly to save their businesses from destruction, but the city council ultimately rejected the motion. See and his mother watched as bulldozers razed his business. (Photograph by Eddy See, courtesy of Leslee See Leong.)

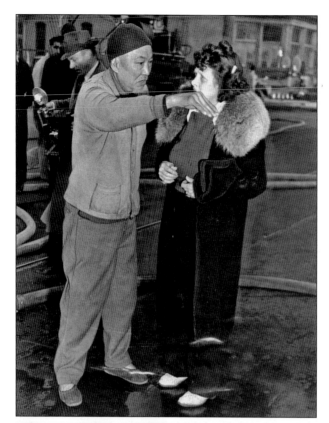

Socialite Christine Sterling, who spearheaded the development of China City and Olvera Street as tourist attractions, consults with Liem Siep during a major fire in China City. (Courtesy of the Herald Examiner Collection/ Los Angeles Public Library.)

Because of its hasty construction, China City suffered from a series of fires that ultimately led to its closure in the 1950s. (Courtesy of the Security Pacific Collection/ Los Angeles Public Library.)

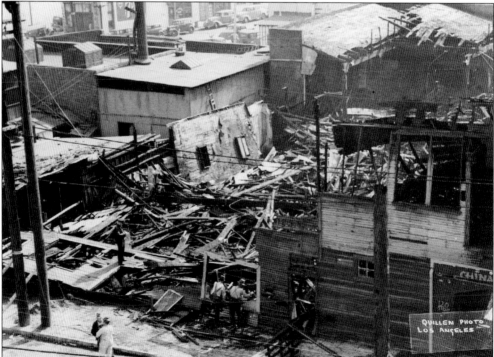

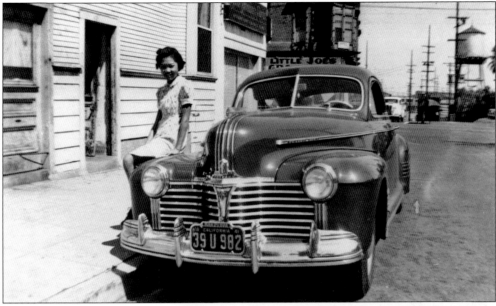

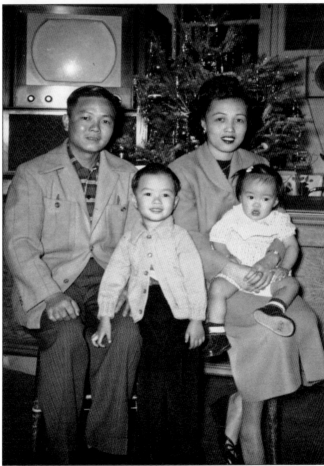

Perched on top of a shiny car, Betty Quong embodies the cool, hip style of second-generation Chinese Americans in the 1950s. Behind her is Little Joe's Grocery, an Italian American business that remained in Chinatown after the Italian American community moved to the suburbs. The grocery store and restaurant eventually closed its doors well after this 1951 picture. (Courtesy of the Shades of L.A. Archives/ Los Angeles Public Library.)

Wing and June Soo-Hoo celebrated Christmas with their children, Al and Elsie, on December 25, 1951. The family lived and worked at their store, South China Gifts, which was opened by Wing's father, Sung Soo-Hoo. South China Gifts was located on Gin Ling Way in Central Plaza. (Courtesy of Al Soo-Hoo.)

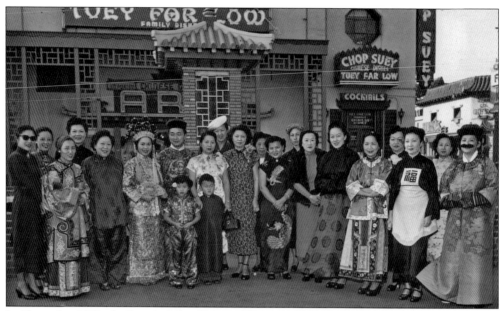

In November 1951, the Los Angeles Chinese Women's Club (LACWC) held a fashion show to demonstrate the customs of a traditional Chinese wedding. Founded in 1944, LACWC was highly active in various civic and cultural affairs that affected Chinatown and the Chinese American community in Los Angeles. LACWC was affiliated with the California Federation of Women's Clubs and held monthly meetings in various members' homes. (Courtesy of the Herald Examiner Collection/Los Angeles Public Library.)

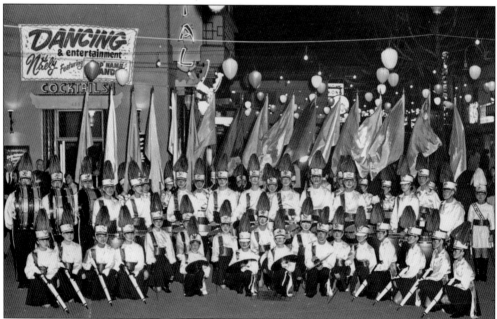

The Los Angeles Chinese Drum and Bugle Corps was founded by William Lee in 1954 with the goal of building community, understanding, and harmony between ethnic groups. Their motto was "One for All and All for One." Pictured here in Central Plaza, the membership consisted of boys and girls between the ages of 10 and 21. (Courtesy of Charlie Quon.)

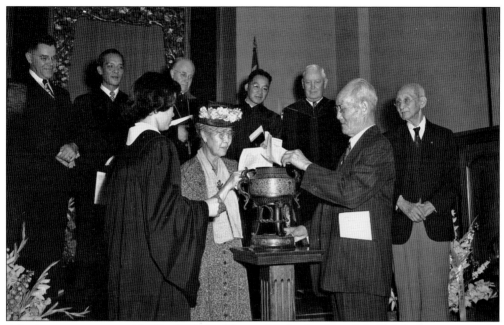

After its mortgage was paid off in 1950, the Chinese Methodist Church held dedication services for their building at 825 North Hill Street. Maxine Jue stands to the left of Mrs. K. S. Chan and Jung Kam as they burn the mortgage papers in a special urn prepared for the ceremony. Behind them are J. Wesley Hole, Rev. Wun Bew Wong, Bishop Donald H. Tippett, Rev. Edwar Lee, George A. Warmer, and S. K. Chan. The church held its first services at 204 Marchessault Street in 1887. It moved to the Lugo House on Los Angeles Street in 1893 and remained there until the structure was torn down to build the Hollywood Freeway. Although the congregation had inhabited the building since 1947, Methodist doctrine stated that the church could not be dedicated until it was entirely debt-free. The new building was designed by Gilbert Leong. (Courtesy of UCLA.)

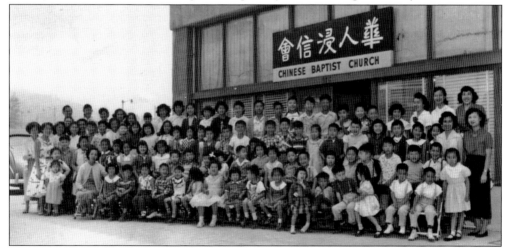

Pictured here in 1955, the First Chinese Baptist Church held its initial services in a converted noodle factory on Hill Street. The church was founded in 1952 by Rev. Manly Rankin and eventually expanded its holdings to include a classroom and office space at 942 Yale Street. In 2001, a brand-new sanctuary was dedicated at 949 Yale Street to accommodate a growing congregation of over 2,000 members. (Courtesy of the First Chinese Baptist Church.)

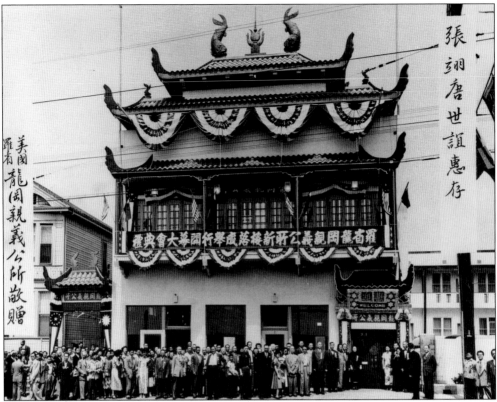

The Lung Kong Ting Yee Association (four families) held a grand opening celebration for its new building at 989 North Broadway Street in 1949. Members share one of four surnames that trace back to four blood brothers: Chew, Chang/Cheung, Lau/Liu, and Quan. (Courtesy of the Shades of L.A. Archives/Los Angeles Public Library.)

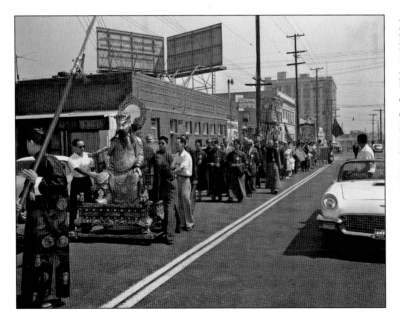

Members of the Kong Chow Benevolent Association bring the statue of Kwong Kong down Broadway Street to their new location at 931 North Broadway Street. The statue was in storage for 11 years after the old Kong Chow Temple on Ferguson Alley was torn down to make way for the Hollywood Freeway. (Courtesy of UCLA.)

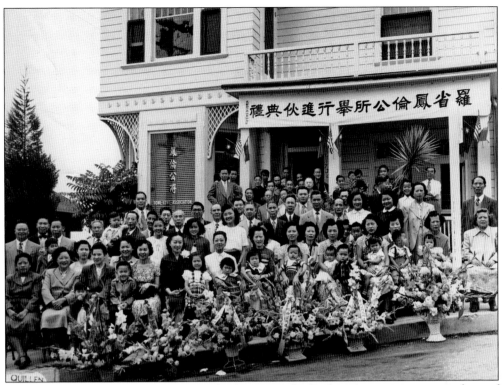

Members of the Fong Lun Association, also known as the Soohoo Association, pose in front of their headquarters at 730 Hill Place. Walter SooHoo, owner of Phoenix Imports and Hop Louie in Central Plaza, stands next to the center post. The house was later torn down to build a new structure for the association. (Courtesy of the Shades of L.A. Archives/Los Angeles Public Library.)

To meet the banking needs of the underserved Chinese American community in Los Angeles, Cathay Bank opened its doors in 1962. When cofounder F. Chow Chan's application for a savings and loan institution was repeatedly rejected, law professor Preston Martin advised that the Phoenix Bakery owner and his group apply for a commercial bank charter instead. As a result, Cathay Bank became the first Chinese American bank in Los Angeles. (Courtesy of Cathay Bank.)

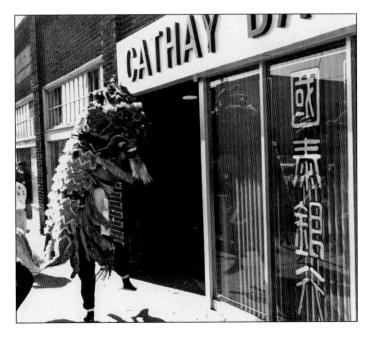

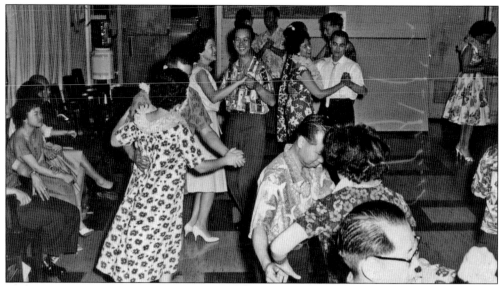

As more and more Chinese Americans moved out of New Chinatown and headed for the suburbs, the Chinese American Citizens Alliance sponsored activities such as Hawaiian Dance Fridays to bring members back to the community for an evening of socializing and physical fitness. CACA member Peter SooHoo Jr. smiles brightly from the dance floor in 1961. (Courtesy of Peter SooHoo Jr.)

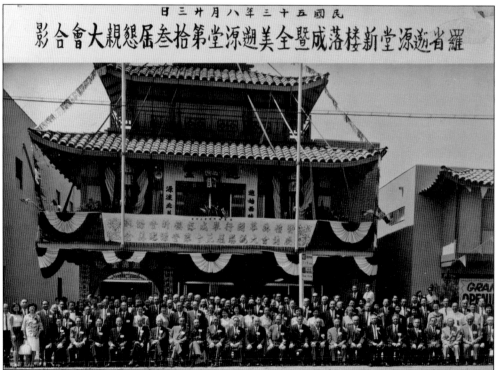

In August 1964, the Soo Yuen Fraternal Association celebrated the grand opening of their new building at 993 North Broadway Street. The association consists of almost 200 members who share one of three surnames—Fong, Kong, or Louie. (Courtesy of the Soo Yuen Fraternal Association.)

Richard Nixon met with members of the Chinese American Citizens Alliance during his 1962 campaign for governor of California. Nixon is flanked by attorney Y. C. Hong (left) and CACA president Wilbur Woo (right). Nixon ultimately lost the election by less than 4 percent. (Courtesy of the You Chung Hong and Mabel Chin Hong Archives.)

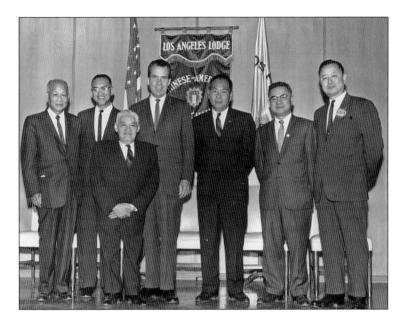

During his bid for governor, Ronald Reagan visited Central Plaza and met with members of the Chinese American Citizens Alliance. Reagan served as governor of California from 1967 to 1975. Attorney Y. C. Hong stands at left. (Courtesy of the You Chung Hong and Mabel Chin Hong Archives.)

The Los Angeles Chinatown Democratic Club was the first Chinese American political club to be chartered in Southern California. It was organized in 1959 with first president Calvin Chang, who holds the framed charter. From left to right are Evelyn Benson, Lupe Gutierrez, Wellington Kwan, May Louie, Tommy Enriquez, Clara Chin, Calvin Chang, Phoebe Gee, Walter Chung, Dolores Wong, Billy Lew, and Kwock Wing Louie. (Courtesy of El Pueblo de Los Angeles Historical Monument and the Chinese American Museum.)

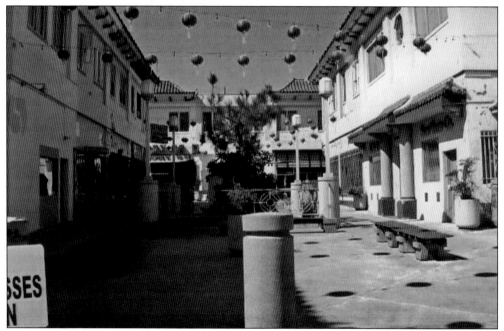

In 1948, the West Plaza (also known as Chungking Plaza) opened across Hill Street (formerly Castelar Street) as an extension of Central Plaza. It featured commercial and gallery spaces on the first floor and living quarters on the second floor. Chung King Road was named to commemorate the capital of China during World War II. It now consists of mostly art galleries, which contribute to Chinatown's growing reputation as an international art scene. (Courtesy of Francine Redada.)

Cinematographer James Wong Howe was a regular at Grand Star Restaurant, which was operated by the Quon brothers, Wally (left) and Frank. Howe won two Academy Awards for Best Cinematography for the films *Hud* and *The Rose Tattoo*. (Courtesy of Wallace Quon.)

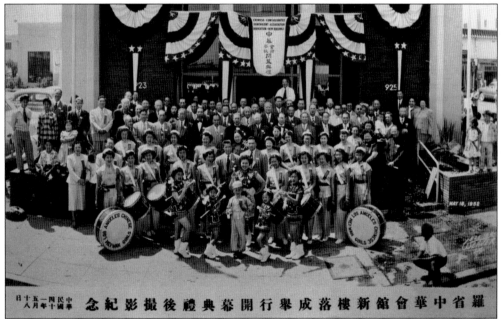

Founded in 1890, the Chinese Consolidated Benevolent Association was the main governing organization for the Chinese community in Los Angeles. Each association, organization, and business in Chinatown would send two annual delegates to CCBA as their representatives. CCBA held monthly meetings to arbitrate disputes, provide assistance to immigrants, and decide on matters affecting the Chinese community. Originally housed in the Garnier Block in Old Chinatown, CCBA inaugurated its new building on May 18, 1952.

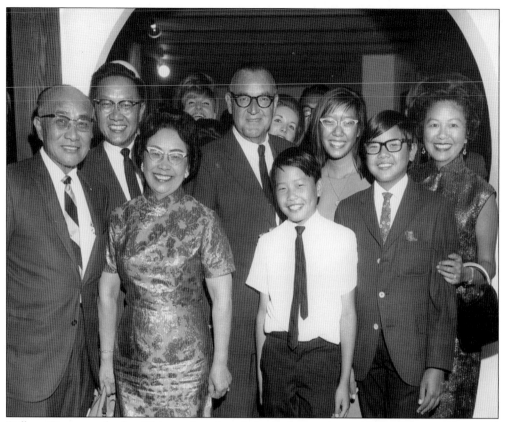

Delbert Wong was the first Chinese American judge in the continental United States. Wong and his wife, Dolores, were highly active in the Chinatown community. In 1959, Wong was appointed by Pat Brown to the Municipal Court of the Los Angeles District. This 1962 photograph shows the Wong family demonstrating their support for Brown, who defeated Richard Nixon in the California state election. Pictured from left to right are Earl Wong, Delbert Wong, Alice Wong, Gov. Pat Brown, Kent Wong, Shelley Wong, Duane Wong, and Dolores Wong. (Courtesy of El Pueblo de Los Angeles Historical Monument and the Chinese American Museum.)

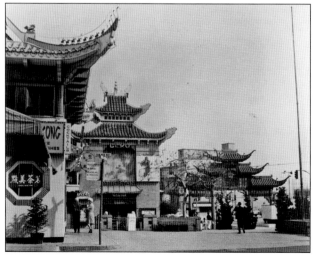

This view of Gin Ling Way in Central Plaza shows Li Po Café, which was named after a famous Chinese poet. Tyrus Wong's mural is above the entrance.

Four

NEW GENERATIONS IN CHINATOWN

Alpine Recreation Center is the only sports facility open to the public in Chinatown. It consists of three basketball courts, meeting spaces, a kitchen, playground, and an open lawn. (Courtesy of Visual Communications Photographic Collections.)

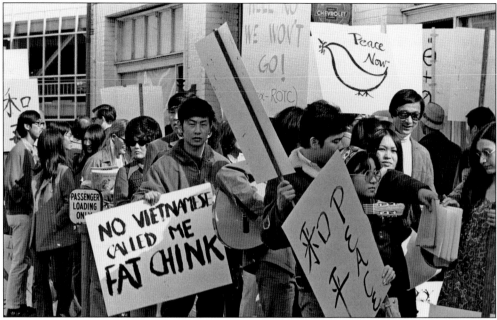

During the late 1960s and early 1970s, a new generation of Chinese American activists became involved in movements at home and abroad. Asian American activists organized a series of protests against the Vietnam War, including this one in downtown Los Angeles. (Courtesy of Visual Communications Photographic Collections.)

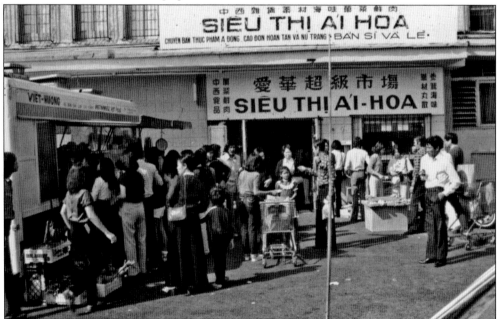

The Vietnam War and Cambodian genocide resulted in successive waves of refugees to the United States—many of who settled in Chinatown. Southeast Asian businesses and organizations quickly sprung up to accommodate the new arrivals. Located on College Street, Sieu Thi Ai Hoa market sells groceries and meal items to a new demographic in Chinatown, where trilingual signs are now a common sight. (Courtesy of Paul Louie.)

Chinatown's population increased dramatically as a result of the influx of refugees from Southeast Asia, as well as immigrants whose arrival was facilitated by the Immigration Act of 1965. This law raised the total number of visas for immigrants from Asia to 170,000, with a maximum cap of 20,000 visas per Asian country. (Courtesy of UCLA.)

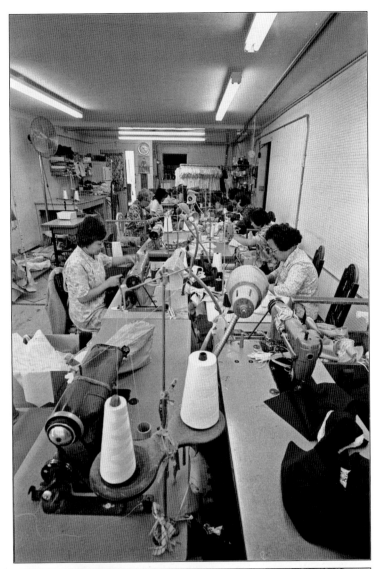

Asian American activists organized demonstrations to demand an improvement in social services and health care for Chinatown's residents, especially its senior citizens. In the early 1970s, the community picketed Resthaven Psychiatric Hospital to protest against its lack of resources for Chinatown's residents. (Courtesy of Gilbert Hom.)

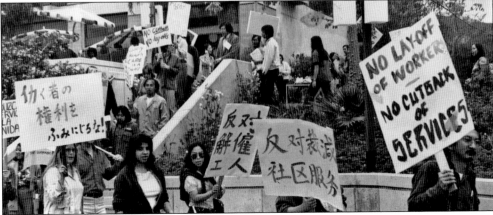

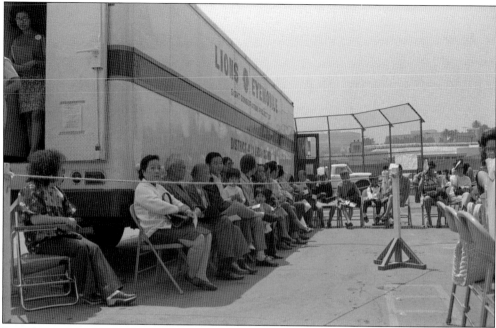

Long lines were a common sight during Chinatown Health Day, which provided free medical services to the neighborhood's residents. During the 1970s, most residents in Chinatown did not have access to health care or could not afford medical insurance. (Courtesy of Visual Communications Photographic Collections.)

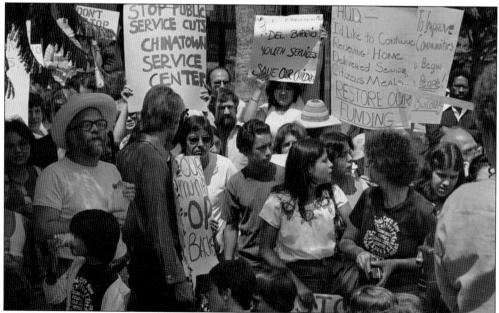

Founded in 1972, the Chinatown Service Center provides health, housing, and advocacy services to residents of Chinatown, as well as communities throughout Southern California. Cuts in services sparked a public outcry and protests from the Chinatown community, which relied heavily on the only social services agency in the neighborhood. (Courtesy of Visual Communications Photographic Collections.)

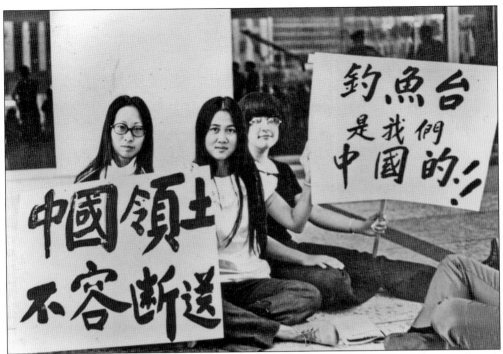

Pictured are, from left to right, Esther Lam, Gay Yuen, and Sheila Yu who protested against Japan's claim to the Ryuku Islands. Yuen is currently the vice president of the Friends of the Chinese American Museum. (Courtesy of Gilbert Hom.)

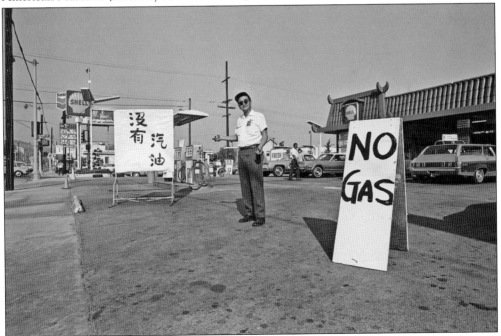

The Oil Crisis of 1973 affected the entire country, including Chinatown. Operator Kaz Hirata stands next to bilingual signs that indicate his service station is out of gas. Gas rationing and long car lines at service stations were common during this period. (Courtesy of UCLA.)

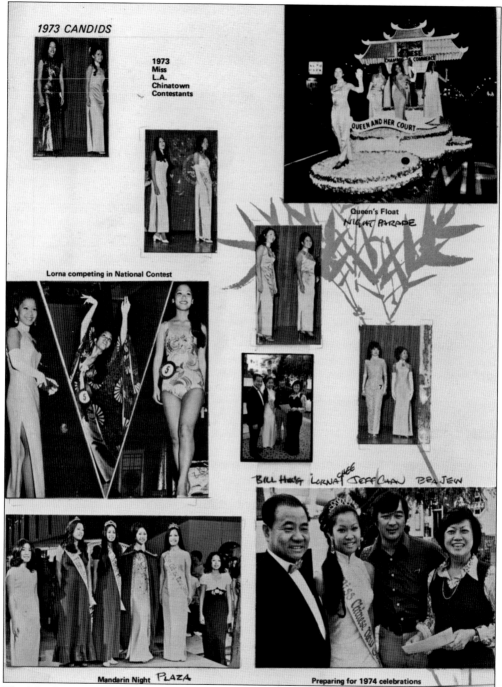

The Miss Los Angeles Chinatown pageant is organized by the Chinese Chamber of Commerce of Los Angeles. The Los Angeles pageant is among the most inclusive in the United States, with contestants having at least one-quarter Chinese ancestry and falling between ages 18 to 26. Pictured in the lower right photograph, Bill Hong ran the Hong Kong Low restaurant, which opened on the former site of Joy Yuen Low. Jeff Chan is a longtime supporter of the pageant and founder of the Immortals Awaken Lion Club. (Courtesy of Jeff Chan.)

Under a federal Title VII grant, Castelar School implemented two bilingual programs in Spanish and Cantonese for its students. Castelar students benefited from the Asian American Tutorial Project, which was founded in 1969 by college students who wanted to reach out to the rapidly growing community. Tutors from UCLA, Cal State Los Angeles, University of Southern California, and Occidental College participated in "Saturday School," where they assisted approximately 100 to 150 Castelar students in various subjects.

Chinatown Teen Post (formerly Chinatown Youth Council) was a government-funded youth center that opened at 971 Chung King Road in September 1971. The organization was initiated by college students who wanted to develop positive outreach programs for the youth and the community. Activities included dances, field trips, sports, picnics, educational programs for youth, and ESL classes for adults. Chinatown Youth Council also published a bilingual newspaper, offered child care, and screened Chinese films for the community. (Courtesy of the Chinese Chamber of Commerce.)

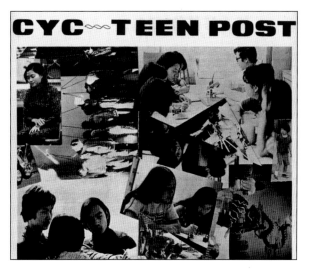

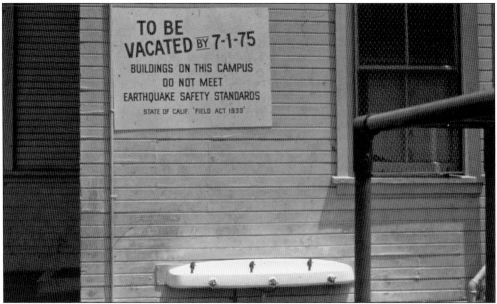

The wooden structure of Castelar School was condemned for demolition because it did not meet earthquake standards. By July 1, 1975, the building was completely vacated. The new building was designed by Choy and Associates and featured 27 classrooms, a multipurpose room, and a children's center, with landscaping donated by the Chinese Consolidated Benevolent Association.

The ground-breaking ceremony of the new Castelar School building was held in 1977. Castelar students and principal William Chun-Hoon joined March Fong Eu at the opening ceremony. Pictured at the far left, Chun-Hoon was the first Chinese American principal in the Los Angeles Unified School District. As California secretary of state, March Fong Eu was the first Asian American woman to be elected to a state constitutional office in the United States.

Chinatown did not have a public library before the 1970s. The rapid influx of new immigrants highlighted the need for multilingual reading materials that would serve the Chinatown community. The public library service began with a bookmobile stop at Castelar School and was expanded to include a second stop at Bank of America in 1973. (Courtesy of William Chun-Hoon.)

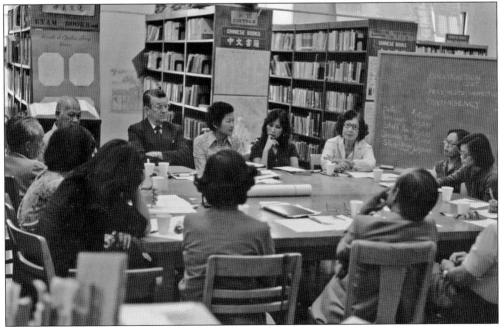

Within its first three months, the success and overcrowding of the Chinatown library and Castelar School necessitated immediate planning meetings of library, school, and community representatives to expand the 2,600-foot auditorium space that housed the library. Among the attendees were, from left to right, (first row) Dolores Wong and Sam Joe; (second row) Juliana Cheng, John Chin, Frank Chee, Byron Kimball, Ruby Ling Louie, Chris Ung, Grace Wong Chow, unidentified, and Suellen Cheng. (Courtesy of Ruby Ling Louie.)

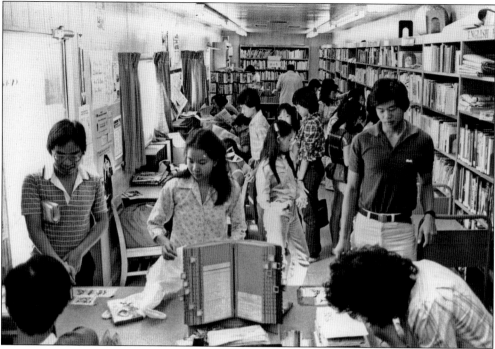

Having secured two Housing and Community Development grants for an expansion, the Friends of the Chinatown Library rented an air-conditioned 10-by-50-foot trailer to house the Chinatown library from 1981 to 1982. The construction pledge of $227,000 was received from an extended network of community donors. (Courtesy of Ruby Ling Louie.)

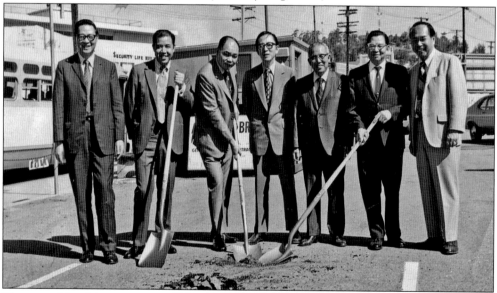

The ground-breaking ceremony of Mandarin Plaza occurred in 1973. Located at the intersection of Bernard and Broadway Streets, the shopping center represented the arrival of post-1965 wealth and immigration to Chinatown. Attendees included Bob Gee, Davis Chen, Jack Lee, Dan Jeng, Poy Wong, and Wilbur Woo. (Courtesy of El Pueblo de Los Angeles Historical Monument and the Chinese American Museum.)

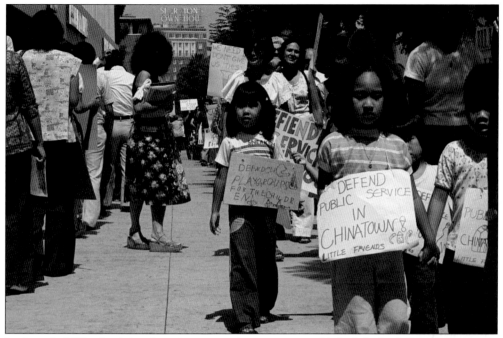

In the early 1970s, the Asian American women's movement established the Little Friends Playgroup, a childcare center for working families in Chinatown. These little friends joined their parents to protest against cuts in public services that affected the entire community. (Courtesy of Visual Communications Photographic Collections.)

Gim Fong was born in Old Chinatown in 1931. His father, Fong Yun, opened Fong's Oriental Works of Art on Ord Street and then moved to Chung King Road in 1952 after the first store burned down in a fire. Pictured here, Gim Fong took over the business in 1972 after his father passed away. Father and son were members of the pioneering Fong family, whose legacy spans over a century in Old and New Chinatown. Fong was a beloved member of Chinatown's business community who worked in the store until his death in 2005. (Courtesy of Shay McAtee Photography.)

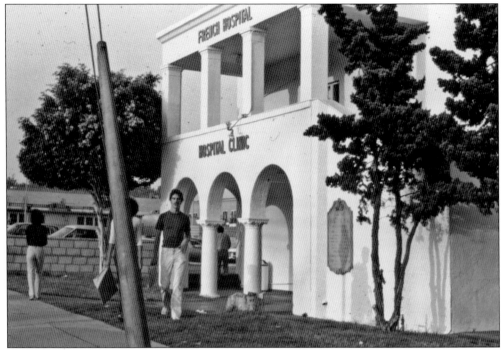

The French Hospital was built in 1869 by the French Benevolent Society and was a pioneer for its policy of serving patients from all backgrounds. It was the second oldest hospital in Los Angeles until it filed for bankruptcy in 1989. In 1991, the hospital reopened as the Pacific Alliance Medical Center, with an outside statue of Joan of Arc continuing to pay tribute to the former French community. (Courtesy of Paul Louie.)

Wonder Bakery opened its doors at 943 North Broadway Street in 1973. General manager Chris Cheung and his wife, Margaret, represent a new generation of Chinese Americans who arrived in Chinatown from Hong Kong after passage of the 1965 Immigration Act. Cheung (at left) and his staff prepare for the Moon Festival celebration in Central Plaza, where they will introduce visitors to delicious varieties of moon cakes.

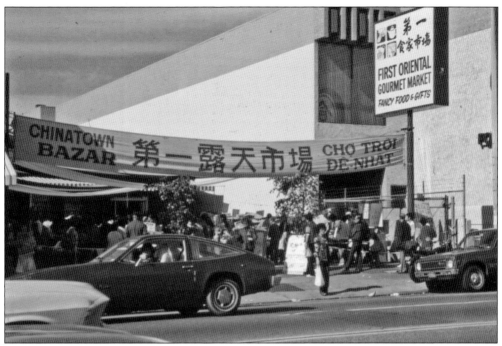

The Chinatown Bazaar was an early predecessor of the current Chinatown Farmer's Market and Saigon Plaza, which provide outdoor shopping venues for local merchants.

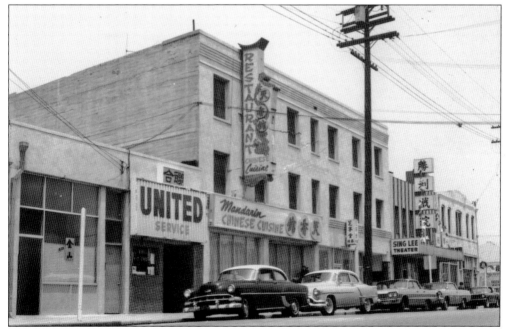

The Sing Lee Theater on Spring Street presented Chinese films and opera to the community.

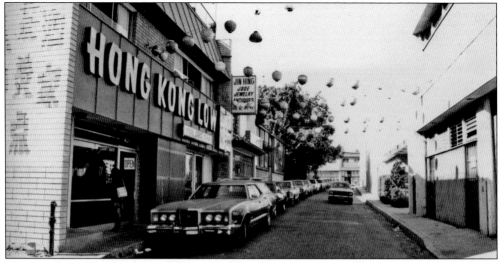

This snapshot of Bamboo Lane in the 1970s shows the rear entrance of Hong Kong Low restaurant, which has since closed down. It also features Jin Hing Jewelry, which dates back to Old Chinatown and is one of the longest-running businesses in New Chinatown. The Chinese American Citizens Alliance moved to 415 Bamboo Lane after its original location in the Garnier Building was torn down. Bamboo Lane has since become a trendy destination for galleries, artists, and patrons who represent a new demographic in Chinatown.

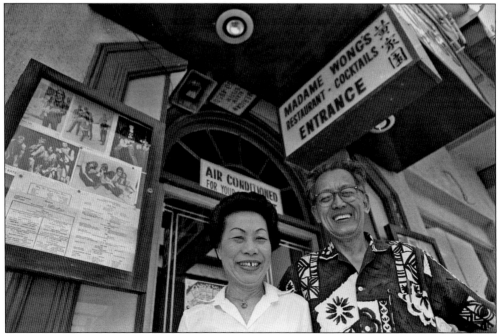

Rock 'n' roll came to Chinatown when the owners of Madame Wong's opened their doors to local bands in 1979. George and Esther Wong started the business in 1970 and provided entertainment from groups such as the Polynesian Maidens. To attract more audiences, the club began booking bands such as the Motels, Oingo Boingo, the Go-Gos, 20/20, and the Police. Esther Wong became affectionately known as the "godmother of punk," even after Madame Wong's in Chinatown closed down in 1985. (Courtesy of UCLA.)

The grand opening of East West Bank occurred in January 1973. Phoenix Bakery owner Fung Chow Chan spearheaded the effort to create the first Chinese American savings and loan institution to receive a charter from the federal government. East West Bank benefited from the efforts of the Minority Bank Outreach Program, which targeted Asian, Latino, and African American communities. The program was led by Preston Martin, chairman of the Federal Home Loan Bank under Richard Nixon's administration. Chan takes a photograph of attorney Betty Tom Chu during the opening ceremony. (Courtesy of Kellogg Chan.)

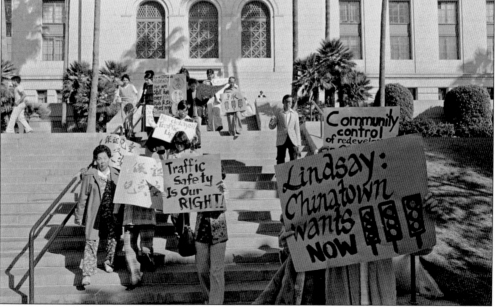

After a Castelar student was tragically killed in a car accident in 1979, the Chinatown community held a demonstration at Los Angeles City Hall to protest against the lack of traffic lights around the school and throughout Chinatown. The signs are addressed to Councilman Gilbert Lindsay, whose jurisdiction included Chinatown. As a result, stop signs were placed at intersections around the school and a crossing guard was hired to assist children walking across the street. (Courtesy of UCLA.)

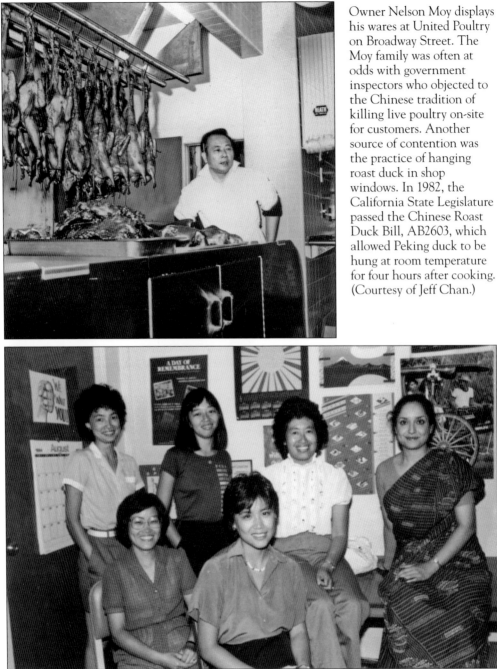

Owner Nelson Moy displays his wares at United Poultry on Broadway Street. The Moy family was often at odds with government inspectors who objected to the Chinese tradition of killing live poultry on-site for customers. Another source of contention was the practice of hanging roast duck in shop windows. In 1982, the California State Legislature passed the Chinese Roast Duck Bill, AB2603, which allowed Peking duck to be hung at room temperature for four hours after cooking. (Courtesy of Jeff Chan.)

In 1978, the Chinese Historical Society of Southern California (CHSSC) joined forces with the Asian American Studies Center at the University of California at Los Angeles to launch an oral history project of Chinese Americans in Southern California. The 165 oral histories were the source material for the stories of Chinese American women in the 1984 book *Linking Our Lives*. From left to right the writers are (first row) Suellen Cheng and Judy Chu; (second row) Marjorie Lee, Susie Ling, Lucie Cheng, and Sucheta Mazumdar. Writers not pictured are Feelie Lee and Elaine Lou.

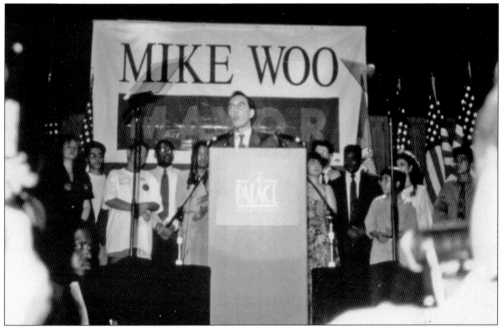

In 1993, Michael Woo made history as the first Asian American to run for mayor of Los Angeles. He was also the first Asian American elected to Los Angeles City Council, where he served from 1985 to 1993. He is the son of Wilbur Woo, former president of the Chinese American Citizens Alliance and long-term Chinatown community leader. This photograph was taken at his campaign party on April 20, 1993—which was primary election night and the beginning of the run-off election campaign. (Courtesy of Michael Woo and Robert Chin.)

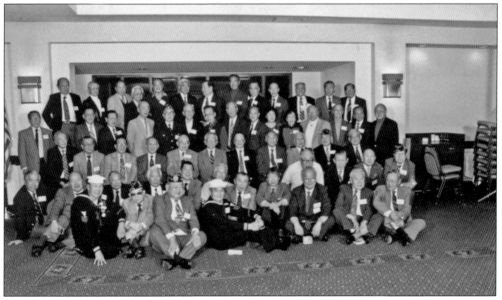

In 1994, Chinese American World War II veterans were honored at a banquet dinner sponsored by CHSSC at Empress Pavilion restaurant. The veterans were featured in the book *Duty and Honor: A Tribute to Chinese American World War 2 Veterans in Southern California*, edited by Marjorie Lee. (Photograph by Franklin Mah.)

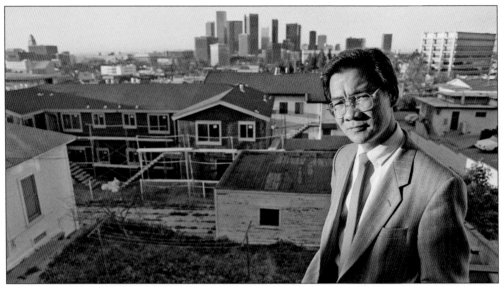

Dr. Haing S. Ngor (1940–1996) was a Cambodian American actor, physician, and author who spent four years in a concentration camp after being expelled from Cambodia by the Khmer Rouge. In 1980, he immigrated to the United States and was later cast in *The Killing Fields* to play Dith Pran, a translator and photojournalist who survived the Cambodian genocide. Ngor's performance earned him a 1985 Academy Award for Best Supporting Actor, which led to additional roles in film and television. He settled in New Chinatown, where he was gunned down in front of his car in February 1996. His legacy continues with the Dr. Haing S. Ngor Foundation, which began under his leadership and funds educational and work projects in Cambodia. (Courtesy of UCLA.)

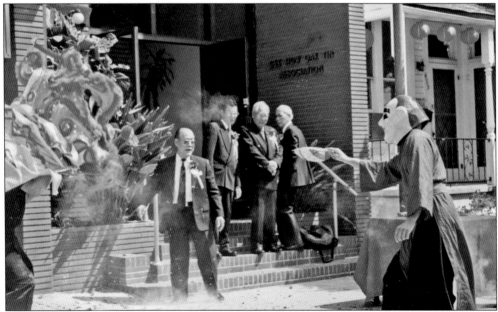

The Gee How Oak Tin Association held an anniversary celebration in 2005. Members share one of three surnames: Chan, Woo, or Yuen. Lun F. Chan, developer of the trademark strawberry whipped cream cake for Phoenix Bakery, joins other members in watching a lion dance performance in front of their headquarters on Bernard Street. (Courtesy of Lun F. Chan.)

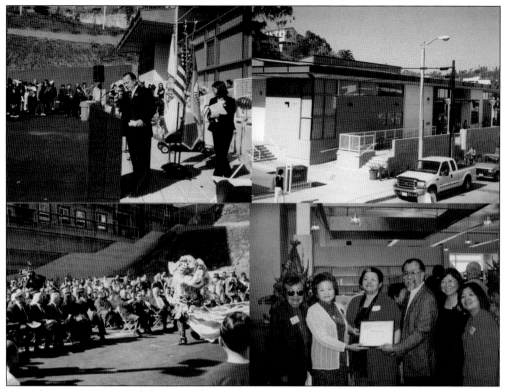

On February 6, 2003, a jubilant crowd representing city, library, and school agencies joined the Friends of the Chinatown Library with all their major donors and community residents to dedicate the new Chinatown Branch Library. Once again, the Friends donated $500,000 to provide 2,000 square feet of additional space to serve not only the Chinatown community, but also the downtown area and the entire city of Los Angeles. (Courtesy of William Chun-Hoon.)

The Chinese Confucius Temple and School on Yale Street opened in 1952 to promote the study of Chinese language and culture. Funds were raised by the Chinese Consolidated Benevolent Association and 27 district and fraternal associations. Enrollment has grown dramatically from 60 students to over 1,000 students. (Courtesy of Francine Redada.)

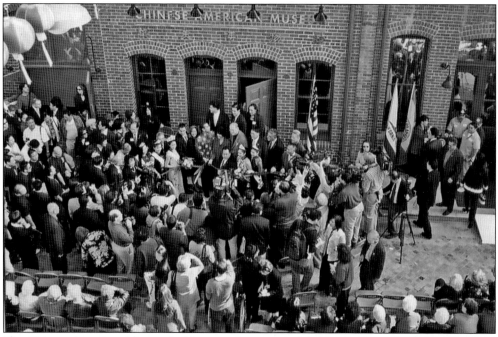

The Chinese American Museum held its grand opening celebration in December 2003. (Courtesy of El Pueblo de Los Angeles Historical Monument and the Chinese American Museum.)

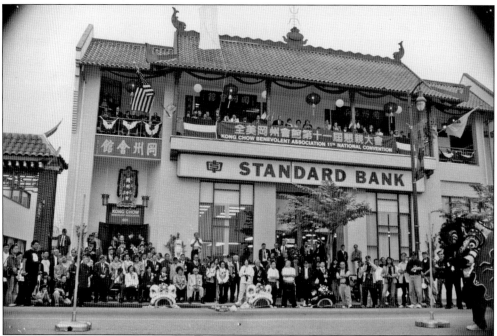

The 11th Kong Chow Benevolent Association National Convention was held in Los Angeles in September 2005. Delegates and members from all over the United States gathered at the Los Angeles headquarters of 931 North Broadway Street to watch this lion dance. Among the honored participants was Judy Chu, chair of the state Board of Equalization, who is seated at the fourth chair from the right. (Courtesy of the Kong Chow Benevolent Association.)

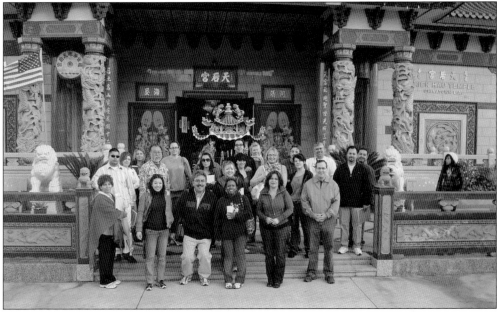

The Thien Hau Temple is located at Yale Street. This Taoist temple covers an area of 6,000 feet, cost an estimated $2 million to complete, and features an annual celebration on Chinese New Year's Eve. Students from Glendale Community College participated in a tour led by Eugene Moy, vice president of programming for the Chinese Historical Society of Southern California.

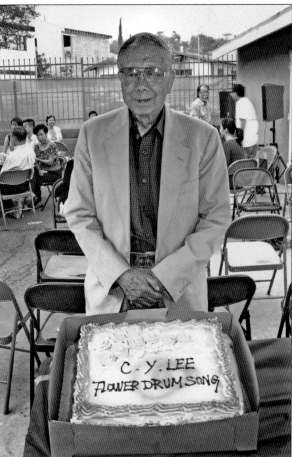

Author C. Y. Lee visited the Chinese Historical Society of Southern California at its annual summer barbecue in 2007. Lee wrote the 1957 novel *Flower Drum Song*, which was adapted into a Tony-nominated Broadway musical and an Oscar-nominated film by the songwriting duo of Rodgers and Hammerstein. (Courtesy of Tom Eng.)

Gallery owner Sam Lee was born in Saigon to a Vietnamese mother and a Chinese father. When he immigrated to the United States in 1977, he was separated from his parents for 10 years. He pursued his love of art history at the University of California at Riverside and opened his first gallery in Chinatown on Hill Street in May 2007.

The Chinatown Public Service Association celebrated its anniversary in May 2008. During the early 1980s, the Chinatown community lobbied the Los Angeles Police Department for a substation in the neighborhood. Chief Daryl Gates agreed to provide police officers if the community could procure a facility. In 1983, CPSA moved into a space donated by Phoenix Bakery owners Fung Chow and Lun F. Chan. With the help of the Los Angeles Community Redevelopment Agency, Friends of CPSA, Jimmy Joe, Fay Gee, and the Community Development Department, CPSA moved to a 3,600-square-foot building at 823 Hill Street. Pictured are, from left to right, Tom Eng, second princess Karin Yi Chieh Lin, Jeffrey Mio, Miss Friendship Tiffany Jennell Kwong, and Phil Lee. Mio and Lee are on the board of directors of the Media Action Network for Asian Americans, which meets in the CPSA building. (Courtesy of Tom Eng.)

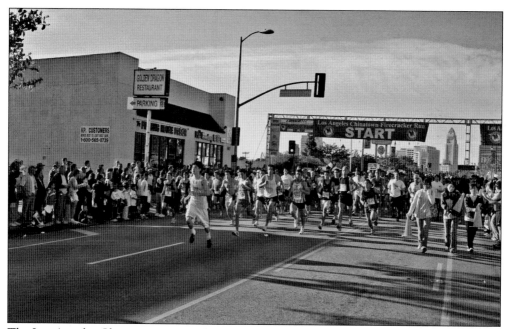

The Los Angeles Chinatown Firecracker Run is held every year during the Chinese New Year festivities. The event was proposed by Helen Young in 1979 as an annual 10K run and eventually expanded to include a 5K Run, 5K Fun Walk, and a 1K Kiddie Run. Proceeds are donated to organizations and programs such as Need2Read, Alpine Recreation Center, Friends of the Chinatown Library, and Chung Wah Chinese School. The races are organized by the volunteer-driven Los Angeles Firecracker Run Committee and have been emceed by Warren Furutani for the past 20 years. (Courtesy of Tom Eng.)

The Chinese Chamber of Commerce was organized in 1955 to promote business and economic development in New Chinatown. In 2008, the organization honored long-term member Irvin Lai with a Lifetime Achievement Award. (Courtesy of Tom Eng.)

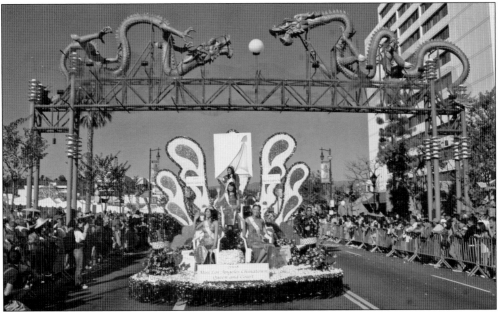

Miss Chinatown and her court ride a float down Broadway Street during the 2008 Chinese New Year parade. Dedicated in 2001, the Dragon Gateway was designed by Rupert Mok as a symbol of luck and prosperity. The building to the right is Cathay Manor, an affordable housing complex for low-income senior citizens that opened in 1984. (Courtesy of Tom Eng.)

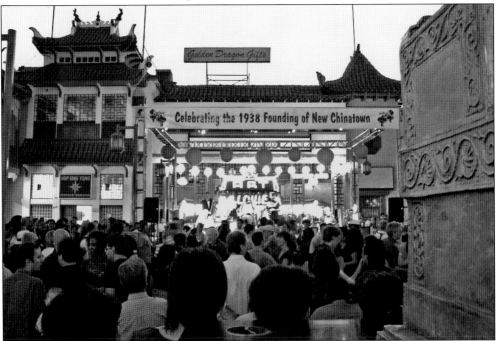

New Chinatown in Los Angeles celebrated its 70th anniversary on June 25, 2008. Cosponsored by the Chinatown Business Improvement District, the evening kicked off with lindy hop and swing dancing, a 1930s fashion show, a presentation on Chinatown's history, and a rededication of the New Chinatown commemoration plaque. (Courtesy of Benjamin Winjum.)

Chinatown Map

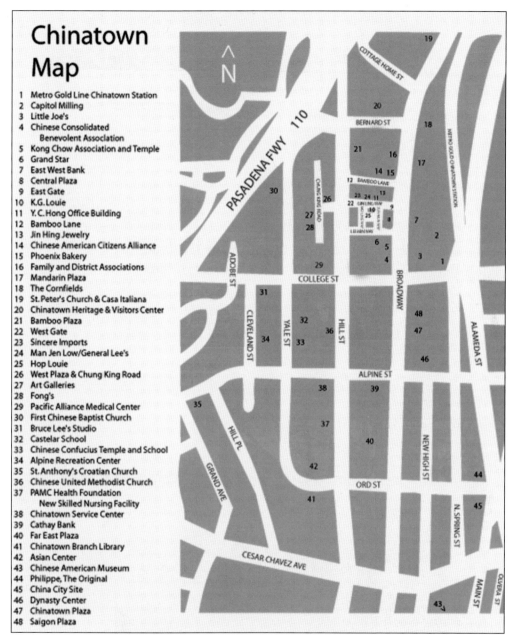

1 Metro Gold Line Chinatown Station
2 Capitol Milling
3 Little Joe's
4 Chinese Consolidated
 Benevolent Association
5 Kong Chow Association and Temple
6 Grand Star
7 East West Bank
8 Central Plaza
9 East Gate
10 K.G. Louie
11 Y. C. Hong Office Building
12 Bamboo Lane
13 Jin Hing Jewelry
14 Chinese American Citizens Alliance
15 Phoenix Bakery
16 Family and District Associations
17 Mandarin Plaza
18 The Cornfields
19 St. Peter's Church & Casa Italiana
20 Chinatown Heritage & Visitors Center
21 Bamboo Plaza
22 West Gate
23 Sincere Imports
24 Man Jen Low/General Lee's
25 Hop Louie
26 West Plaza & Chung King Road
27 Art Galleries
28 Fong's
29 Pacific Alliance Medical Center
30 First Chinese Baptist Church
31 Bruce Lee's Studio
32 Castelar School
33 Chinese Confucius Temple and School
34 Alpine Recreation Center
35 St. Anthony's Croatian Church
36 Chinese United Methodist Church
37 PAMC Health Foundation
 New Skilled Nursing Facility
38 Chinatown Service Center
39 Cathay Bank
40 Far East Plaza
41 Chinatown Branch Library
42 Asian Center
43 Chinese American Museum
44 Philippe, The Original
45 China City Site
46 Dynasty Center
47 Chinatown Plaza
48 Saigon Plaza

This is a street map of New Chinatown. (Courtesy of Jason Dorff.)

ACROSS AMERICA, PEOPLE ARE DISCOVERING SOMETHING WONDERFUL. *THEIR HERITAGE.*

Arcadia Publishing is the leading local history publisher in the United States. With more than 5,000 titles in print and hundreds of new titles released every year, Arcadia has extensive specialized experience chronicling the history of communities and celebrating America's hidden stories, bringing to life the people, places, and events from the past. To discover the history of other communities across the nation, please visit:

www.arcadiapublishing.com

Customized search tools allow you to find regional history books about the town where you grew up, the cities where your friends and family live, the town where your parents met, or even that retirement spot you've been dreaming about.